GOOD FENCES

GOOD FENCES

A Pictorial History of New England's Stone Walls

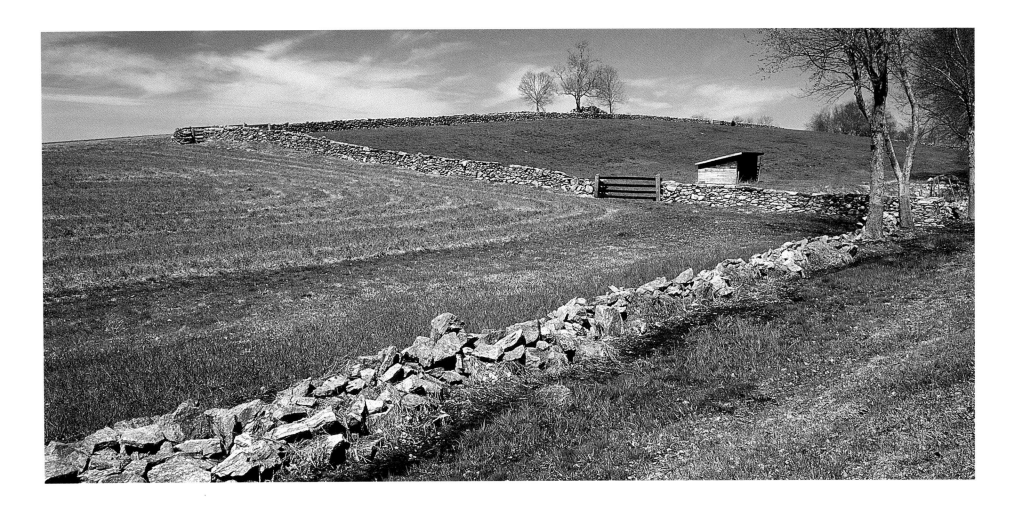

DownEastBooks

William Hubbell

DEDICATION

I am dedicating this book to my father, William B. Hubbell. He was a corporate lawyer in New York City by profession but at heart he was a pioneering farmer. In the early 1930s my parents bought an old, worn-out farm in North Castle, New York, three miles from Bedford and one mile from the Connecticut border. Some of my earliest memories are of him working on the farm walls, repairing those that dated back to the late 1700s—when our house was built—and building new retaining walls for my mother's rock gardens. The spell of stone walls captured me early.

Designed by Carol OBrion
Printed in India

13-digit ISBN 978-0-89272-676-9

COVER PHOTOGRAPH:
This venerable wall segment stands along the ancient "King's Highway," now Route 88 in Cumberland Foreside, Maine, just a few yards from a mileage marker, erected about 1761, indicating it is 136 miles to Boston.

TITLE PAGE PHOTOGRAPH:
A roadside wall, probably made from road construction blast rubble, in the foreground, meets a handsome laid double wall that climbs a hill in Glasgo, Connecticut.

CONTENTS PAGE PHOTOGRAPH:
A rare example of a zig-zag stone wall (see pg. 25).

Down East Books
www.nbnbooks.com
Distributed by
National Book Network
800-462-6420

Library of Congress Control Number: 2006921962

CONTENTS

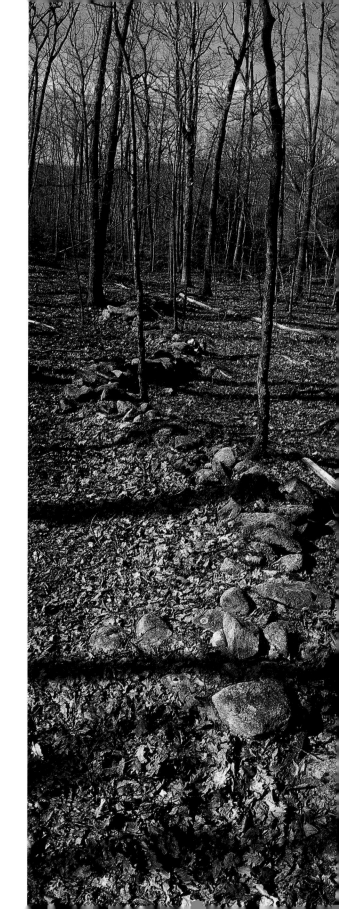

The stone walls of New England stand guard against a future that seems to be coming too quickly. They urge us to slow down and to recall the past.

—ROBERT THORSON, *Stone by Stone*

INTRODUCTION

When I began research for this book, I was amazed by people's enthusiasm for the subject. Everyone with whom I spoke had a favorite stone wall or a story about one. Why do stone walls pique such curiosity? Are we awed by the monumental effort it must have taken to wrest the rocks from the soil? Do these mossy, lichen-encrusted relics act as touchstones to our forebears who originally cleared this land, reminding us of a time and lifestyle long gone from the American scene? To me they are all the above—and more. They are monuments to tenacity and the New England work ethic. They are folk art of great majesty. They bring order and purpose to the New England landscape.

Stones have been with us forever. They were likely a human's first weapon and formed some of the earliest tools. A stone barrier kept wild beasts out of the cave. Stone castles protected the rulers and stone cathedrals inspired worship. It is little wonder, then, that we feel a kinship to them.

I remember riding on my father's shoulders through the fall woods as he walked down to the Mianus River Gorge, a half-mile behind our house. He loved to inspect the network of stone walls that spun their strong web across the relatively flat terrain before it pitched into the gorge with its regal stands of old-growth hemlock trees.

It was a wonder to me, even at that young age, that anyone would build walls in the middle of the woods. My dad patiently explained that what is woods today was once pasture land and that one could see for a mile or so across open fields.

We often hiked by his favorite wall—he called it "The Great Wall of China," although it was only three-and-a-half feet high. To my young mind, the name made it very exotic, even though I wasn't quite sure where or what China was.

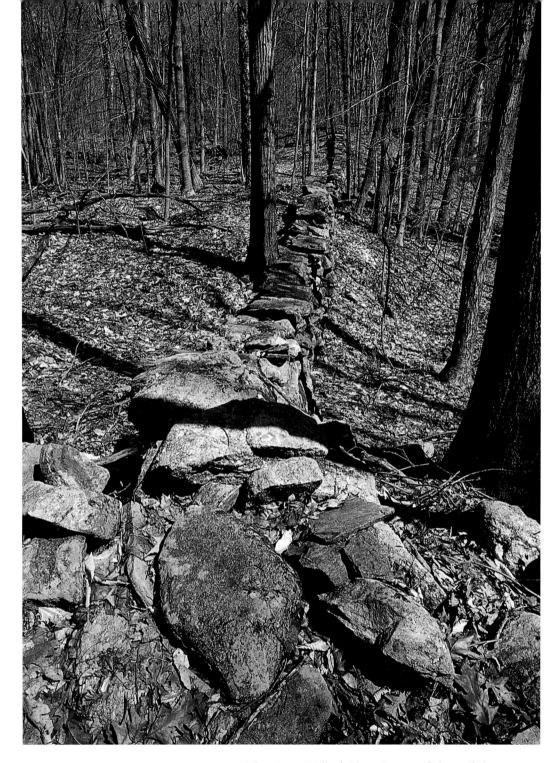

"The Great Wall of China," as my father called it, is more than three feet high and about three-and-a-half feet wide. Depending on what might have been kept in or out, the height could have been raised a foot or so with wooden fencing or brush.

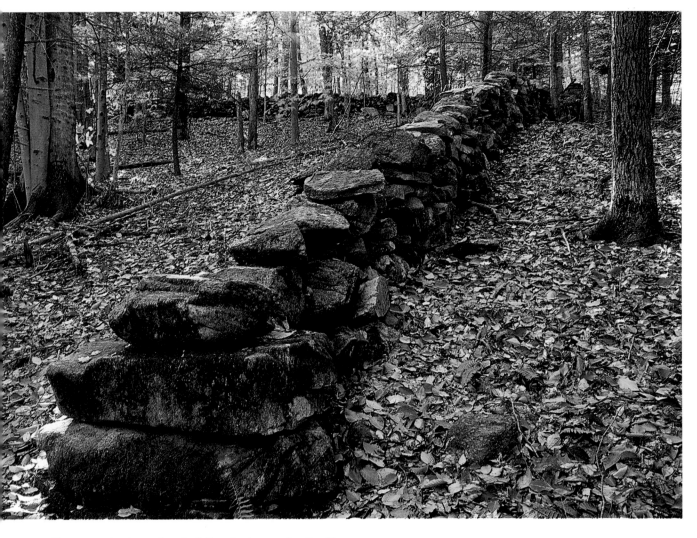

Extra care is given when building the butt ends of walls where they meet a barway or pass-through. Especially heavy stones act like bookends to withstand the pressure from the rest of the wall.

And when visiting the wall today, I find it no less impressive. While the wall would certainly be commanding to a three-and-a-half-foot-tall boy, I am awed as an adult as well. It has snaked across the landscape for nearly two centuries, a full half-mile from the nearest early homestead, still running as square and true as its builders intended. The flat capstones are beautifully in place, right where their builder placed them, though not for beauty but for function. The few stones that have tumbled off are more the result of fallen trees and of hunters than of shoddy workmanship.

As my daughter and I recently walked the familiar woods, I was struck by the regularity of these walls in their placement, one equidistant from the other. Why was this? Why were they roughly the same height? Why were some stones in the walls smooth and without edges and others sharp and angular? The answers to these and many other questions I had while researching this book are contained in the captions, which I hope will be both intriguing and informative.

The photographs in this introduction were taken of the land I roamed as a child. This aerial view provides a glimpse of some of that land, now part of the Mianus River Gorge Preserve, the first Nature Conservancy property, in Bedford, New York. The gorge itself is visible at the very top of the picture. The land was first settled in the mid-eighteenth century and farmed until the early twentieth century. The walls are unusually regular in layout, due primarily to the smoothness of the land.

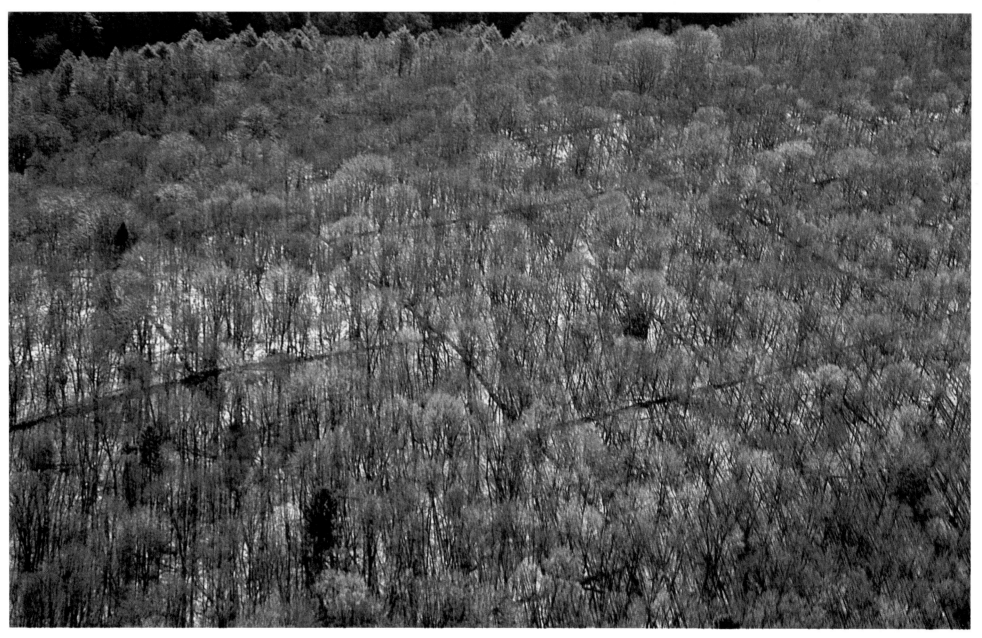

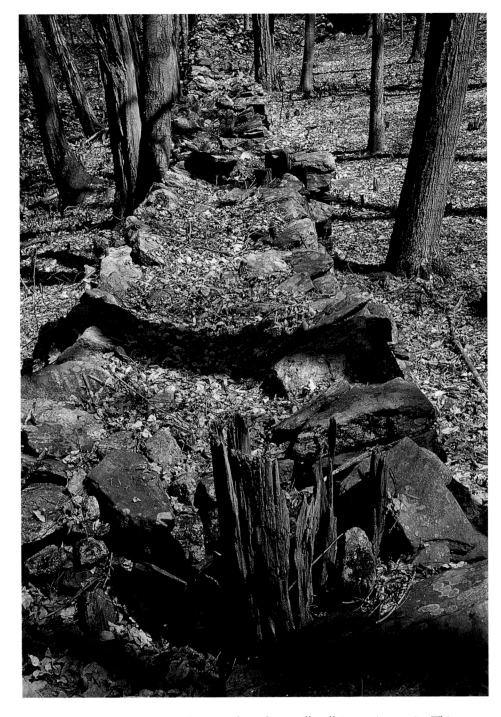

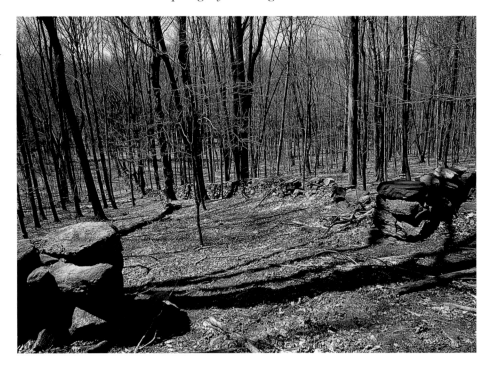

A wide barway such as this indicates that these enclosures were most likely used as hay fields, allowing for the passage of wide wagons.

Seen up close, these walls tell interesting stories. This one contains the nearly decomposed trunk of a chestnut tree. Some eight feet further on, a second can be seen. As the blight that wiped out the chestnut began in 1904, this wall can be dated back to at least the mid-nineteenth century.

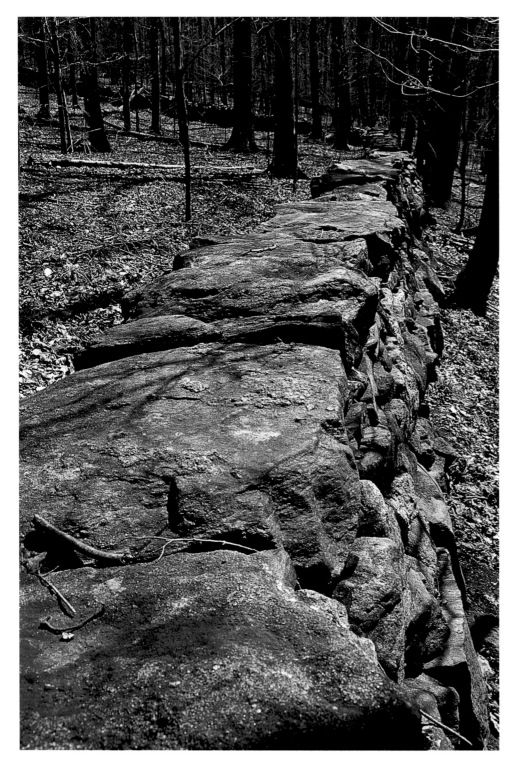

On the west slope of the preserve, this wall, originally built four-and-a-half feet high, shows not only beautifully ordered capstones, but also what happens over time to the uphill side of a wall. It's hard to see in a two-dimensional image, but the uphill side of this wall is one-and-a-half feet high. The downhill side is four-and-a-half feet high. Why? Gravity and erosion during the years that this land was cultivated, along with the natural downward creep of the soil, brought material to the left side while removing some from the right.

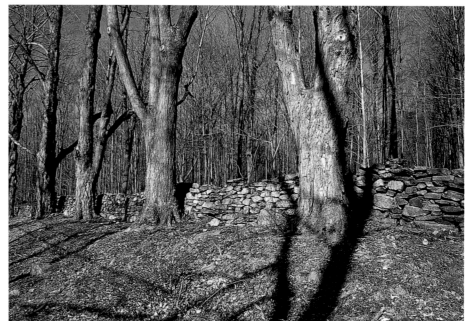

Along a public road, a wall in this network runs behind a row of ancient maple trees. If you look closely, you can see that a large number of the flat capstones have been stolen.

The Ice Age: One Million to 11,000 Years Ago

THE LAND BEFORE MAN

In the beginning there was ice. Lots of ice. Glaciers full of ice. Thirty to forty thousand years ago, the Laurentide Ice Sheet scrunched its bulldozer-like way south across New England from central Canada, spreading like an icy, viscous mass, grinding up everything in its path. This frigid behemoth, well over a mile thick at its center, was the last of between three and seven ice sheets to slide its way southward during the Pleistocene Epoch that began some two million years ago. So much water was locked up in Northern Hemisphere ice at that time that by one estimate the

ice held eight million cubic miles of water. The sea level was lowered by more than 275 feet.

As the ice spread southward, it advanced on a mixture of water and ground rock, sometimes at the rate of inches a day, sometimes not moving at all. When still, the ice froze to the surface. When movement began again, the ice plucked up the material it had frozen to, and dragged it along, sometimes mud and gravel, sometimes huge boulders called *erratics*, and all sizes in between.

The ice sheet ceased its southerly movement

when melting from the warmer climate balanced its forward motion—roughly around sixteen thousand years ago. For maybe the next five thousand years the counter forces of advance and retreat remained in equilibrium. All the while, the glacial conveyor belt continued to bring down masses of material. The material that marks the line of the glacier's farthest reach is called a **terminal moraine**. Cape Cod, Martha's Vineyard, Nantucket, and Long Island mark a section of the terminal moraine in New England.

As it retreated, the ice sheet left behind a true mess—Mother Nature at her sloppiest! This rocky jumble, in general, is called **glacial drift**. Glacial meltwater sorted some of this into clays, silts, and sands, which ended up in lowlands and in ponds and lakes, making up what is called **stratified drift**. These deposits contained few large rocks. Consequently, today there are few stone walls to be seen in these areas.

Living was easier and tilling the soil was a pleasure for those lucky, or canny enough to stake out land over stratified drift. But woe unto the settler whose land was made up of a blanket of unstratified drift,

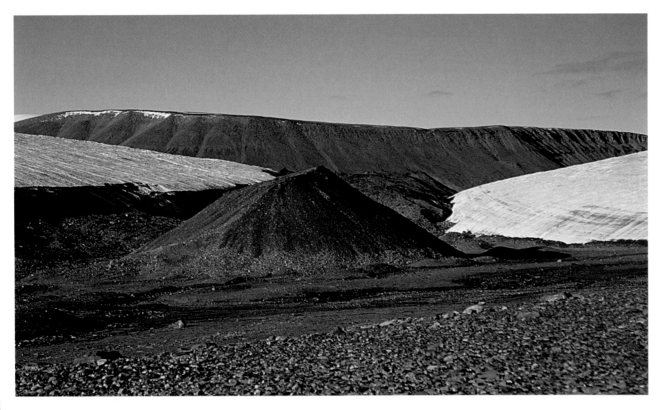

A melting glacier does indeed leave behind chaos. It will be many decades before vegetation might come in to soften this barren landscape on Ellesmere Island in the Arctic Ocean.

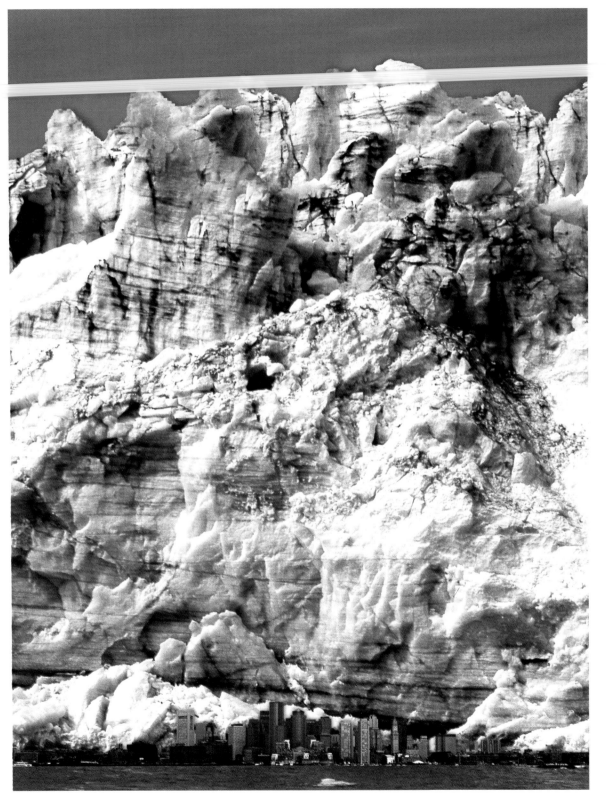

more commonly called ***till***. This material was never tidied up by wind and water. It sprawls over the land just as the glacier dumped it, a helter-skelter mixture of rock and gravel in an infinite variety of sizes.

When the first settlers claimed their land, it was difficult, of course, for them to know what lay beneath the surface. With the retreat of the glaciers came the advance of vegetation. As we shall see, it would be some time before the soil of New England revealed its true character.

Some 20,000 years ago, had there been a Boston, Massachusetts, a glacier a mile thick might have loomed over the city like this. (I credit the idea for this composite image to David Howell, who illustrated Susan Allport's wonderful book on stone walls, Sermons in Stone). *It is always awesome for me to realize how recently this happened. Based on the earth's estimated age of 4.6 billion years, the 20,000 years it took for ice, more than one mile thick, to cover the land where Boston now stands was a mere eye blink.*

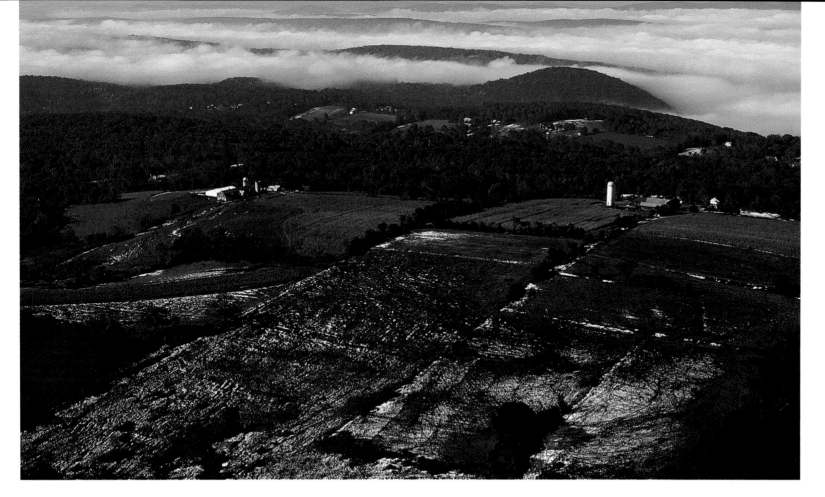

The softly rounded upland topography of central Connecticut indicates it is underlaid by hardpan. Also called **lodgment till**, this layer was the paste that floated the ice sheet, that greased its way across the bedrock. Consequently, due to the incredible pressure of tons of ice, this mixture of mud, sand, and crush-resistant rocks was compressed into a mass nearly cement-like in hardness.

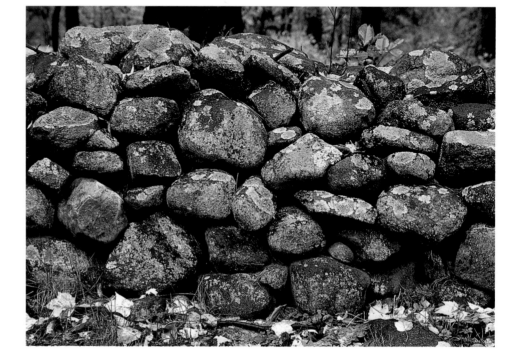

The rocks from this layer, mostly rounded and very hard, were often the first ones to bedevil the early farmers each spring as frost left the soil. This wall is located in Litchfield, Connecticut.

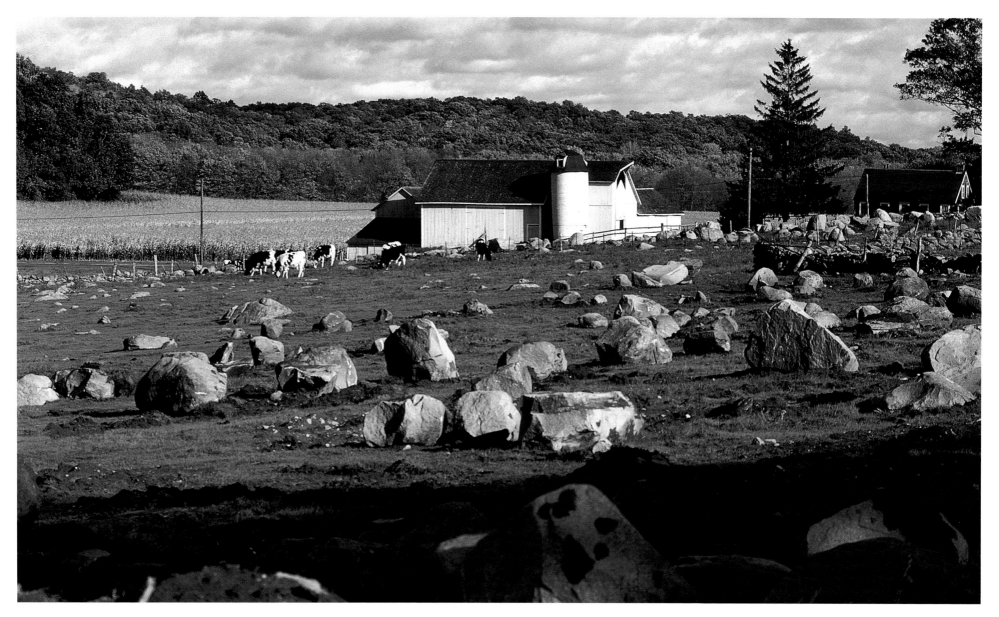

The glacier also left a less compacted layer of debris on top of the hardpan. Called **ablation till** or **meltout till**, it was unceremoniously dumped in an unsorted mess by the glacier during its final melting stage. This material contained mostly angular rocks and gravel, having not been subjected to the crushing, grinding weight of glacial ice. Ablation till is probably the source of this unfortunate farmer's rocky headache. Ablation till, particularly if deposited on a slope where erosion could sweep away smaller particles, was the source of rock for most of New England's stone walls. Being angular, they stacked easily. That zones of lodgment till and ablation till can exist next to each other explains why, when driving along a back road, one can see a wall made mostly of rounded stone and then, a few hundred yards farther, the wall's material is primarily angular, slab-like stone. Imagine tackling this clearing job without power equipment—but it was done that way for nearly three hundred years!

Not all of the glacier's leavings were small enough to be buried. One of the largest known erratics in the world is located in Madison, New Hampshire. Some clever physicist has estimated its weight to be 4,662 tons! What a testimony to the strength of the ice sheet!

Stone walls aren't as ubiquitous in New England as they might seem. In the flood plains of such rivers as the Connecticut and the Farmington, one can drive for miles without seeing a wall, unless the stones were imported.

While the surface of New England's soils may appear benign, what lurks just beneath the vegetation can pack plenty of discouragement. This cross-section of a Maine gravel pit shows a concentration of boulders in the top layer, probably the result of stream action at the time of deposition. The freeze and thaw cycle may well have contributed to the massive amount of rocks just below the surface, right where a farmer would run his plow.

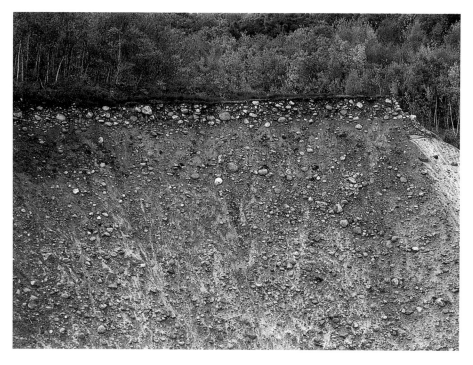

The topography of northeastern Connecticut is typical of land underlain by lodgement till. Stone walls, shaded by trees, separate these fertile fields in Woodstock which have been cultivated for more than three hundred years.

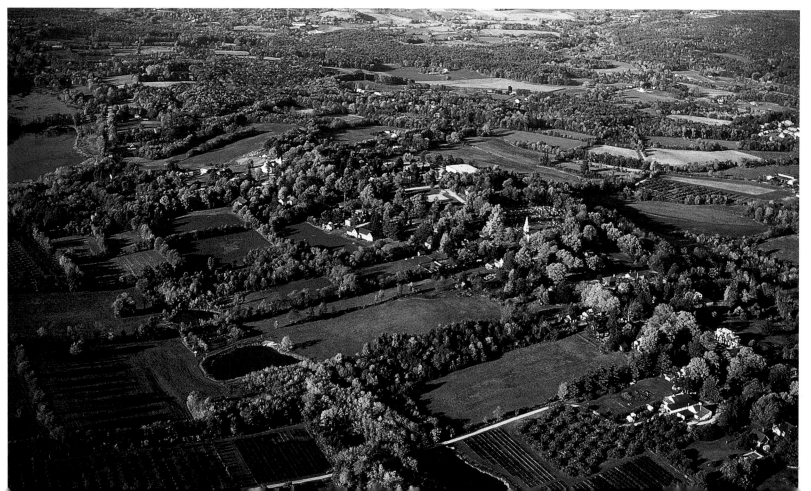

WALL BUILDER: TED PEACH

Ted Peach knows Marblehead, Massachusetts, quite well. It has been home to his family since the mid-1600s. He knows all of Marblehead's twisting, ancient byways and alleyways. And he knows its stone walls. Ted and his forebears have been building and repairing Marblehead's stone walls for more than two centuries.

Ted stands beside a tall, drywall stone seawall on the Marblehead waterfront. "Our family has maintained this for over a century," he says with pride. "This seawall here dates back to probably 1840, or even 1830. And our history with this land goes back even further. The house you see behind me—I have a plot plan that shows that that house was owned by John Peach, my 'way-back' grandfather in the year 1700 and that it overlooked John Peach's Marsh."

Ted's family's style of building walls was ideally to place stones two on one, one on two, with beautifully flat faces and a harmony of size. "That's the ideal," Ted says, "but it depends what you're working with. If you're dealing with rock you've blown out of the ground, you can pick good faced rock. If it's a fieldstone wall, we try not to use the ones like marbles. You use them for fill. I've laid stone the way my great-great-grandfather did and the way his father did. I like laying tight. Dry fit 'em—all drywall construction."

At a beautiful home on the brink of Marblehead Harbor, Ted shows me a stone bulkhead that forms a small pool between the land and the harbor. Ted sits to talk about the wall. "It's a dry wall, built shortly after the Civil War of native stone. One of my jobs is keeping it in repair. I will drive in a repair, rock to rock, so that, if I'm asked to use cement, and the cement goes, the rocks are still there." And what does Ted enjoy most about being a waller? With a big smile, he says simply, "I like playing with granite."

The Primitive Years: 11,000 Years Ago to 1750
THE ARRIVAL OF MAN AND CONSTRUCTION OF THE FIRST WALLS

A spring of sorts came to New England around eleven thousand years ago. As the climate warmed, tundra, a low-growing arctic plant, began to creep into the rocky, barren landscape on the heels of the retreating ice. Grasses, then shrubs and trees, followed in turn to soften the cold, rocky vistas.

Over the centuries, the decaying vegetation carpeted the forest floor with more and more material, creating a deep and fertile soil. Vegetation wasn't the only life form that spread slowly northward across the glaciated landscape. Grazing mammals such as the wooly mammoth and caribou moved in. They, in turn, brought man. Paleo-Indians are documented as having been in New England as early as ten thousand years ago.

The oldest existing stone walls in New England—purported to be those at Mystery Hill in Salem, New Hampshire—have been carbon dated to be four thousand years old using charcoal found above worked bedrock. In Groton, Connecticut, is "Gungywamp," another Paleolithic site that, too, has been dated back four thousand years. Who built them and why remains a mystery, though the structures seem to be astronomically aligned.

The arrival of the colonists really changed the face of New England. With them came centuries of European tradition. Susan Allport, in *Sermons in Stone*, points out that these seekers of religious freedom followed the ancient biblical command from Genesis:

"Be fruitful and multiply and fill the earth and subdue it . . . " She goes on to say that "references to 'subduing the land' appear often in colonial records and accounts. Fencing of all kinds—including stone walls—came to be seen as an unquestionable good, proof of man's intention to improve his lot."

Contrary to common belief, stone walls are not an early form of fencing. Three to four generations passed before the farmers resorted to this labor-intensive, though relatively permanent form of dividing up the landscape. Why? For one reason, there were few stones to be had. The settlers first farmed lands at the coast, where the glacial soils were ample, water-washed, and basically rock free. For another, the settlements in the wooded areas found topsoil a foot or more deep, covering the slumbering rocks with a blanket of fertile humus left from centuries of undisturbed vegetation decay. And even where rocks were present, why would settlers build labor-intensive stone walls when lighter wood was available in abundance?

That some kind of fencing for crop protection was needed soon became apparent. As early as 1633, Plymouth Colony records state that no man should plant corn "without enclosure but at his peril." The earliest fencing was generally made up of the wood and debris created by clearing the land. While the Indians raised their crops around tree stumps and rocks, the Europeans favored the clean and neat, and the orderliness brought about by straight lines.

Over time, deep forests replaced the arid, brown, desolate vistas that remained after the glacier's retreat. The land rested and lay quietly at peace for generations.

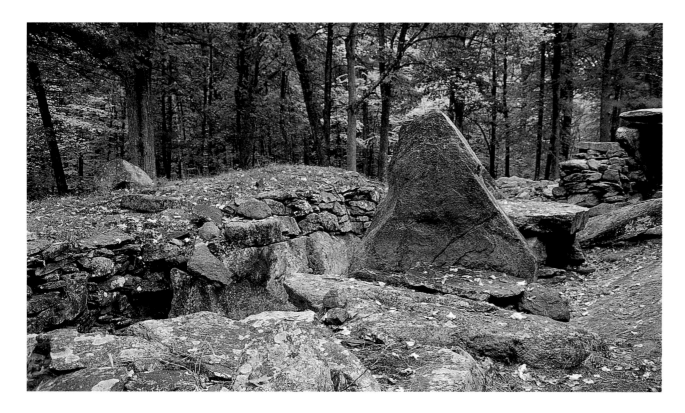

Crude stone structures and walls on Mystery Hill in southern New Hampshire may well be the oldest stone walls in New England, but who built them? A few slabs are quarried stone and weigh several tons. Stone cutting, however, is not a known activity of the woodland Indians. Some people surmise these were built by Celtic priests, or maybe by the same culture that built the English Stonehenge.

After three or four generations of colonists had lived in New England, it became clear indeed that the admonition of Genesis to "... be fruitful and multiply ..." had been well heeded. Due to the subjugation of the Indians, the development of better transportation, the growing population pressures, and, most importantly, a change in attitude of the colonists favoring private versus communal property, groups of pioneers struck out into the deep woods, into the uplands, to make their own way in life.

By the middle of the eighteenth century, the clearing of the wilderness had begun in earnest.

Two roughly concentric circles of quarried stones at the Gungywamp site in Connecticut present another mystery as to who created them and other stone structures nearby, and why.

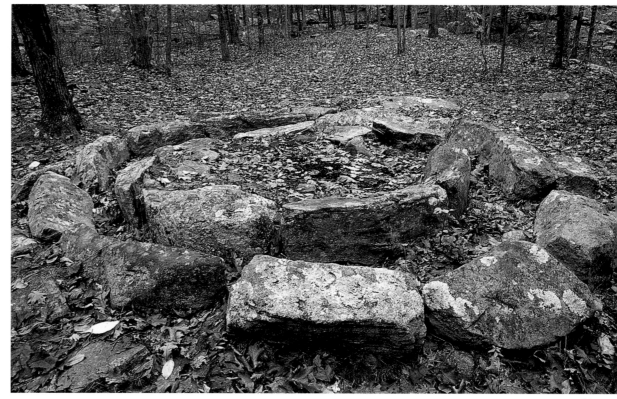

21

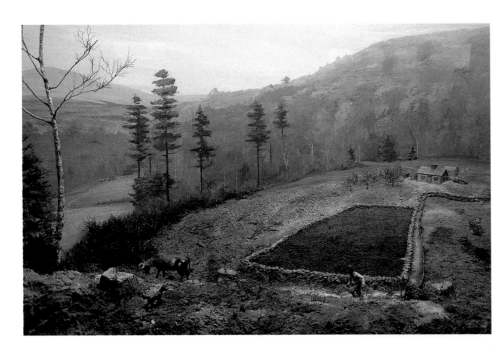

The Fisher Museum at the Harvard University's Harvard Forest in Petersham, Massachusetts provides excellent dioramas depicting the history of New England forests. Three depict periods discussed in this book, beginning with this early subsistence farm, where wood was still being used as fencing, although stones had already accumulated enough for walls. Photos of the other two dioramas may be found on pages 36 and 64. Note that the hillsides beyond the farm were still uncleared and that roads were no more than tracks in the forest.

In prowling New England for unusual walls and interesting locations, I occasionally came across one which would touch a chord deep within. This particular wall, long forgotten in the dense woods of a conservancy property on the Connecticut shore, echoed in silence the magnitude of the effort required to create it—the grunt of the men, the bellow of the oxen, the yells of the children as all worked together to clear a now long-vanished field for planting.

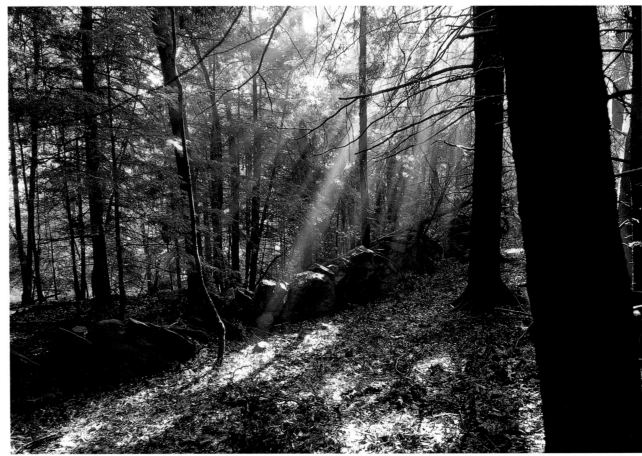

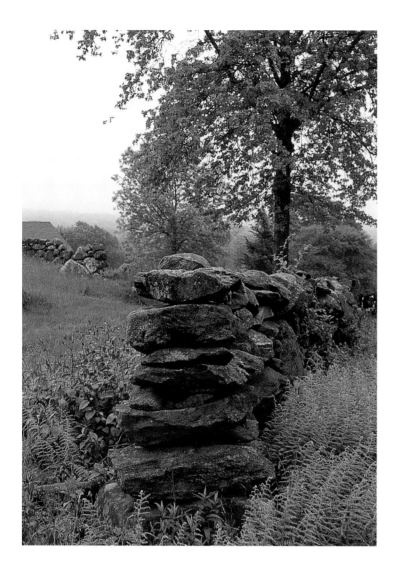

If the supply were sufficient and a pioneer had the time, he might put some order in the stone piles surrounding his fields. Building a **single stack wall** or **farmer's wall** is one of the simplest ways to do this. He would make a line of the largest rocks first, then progressively add smaller and smaller ones to the top to grow the wall in height. It saved much heavy lifting too.

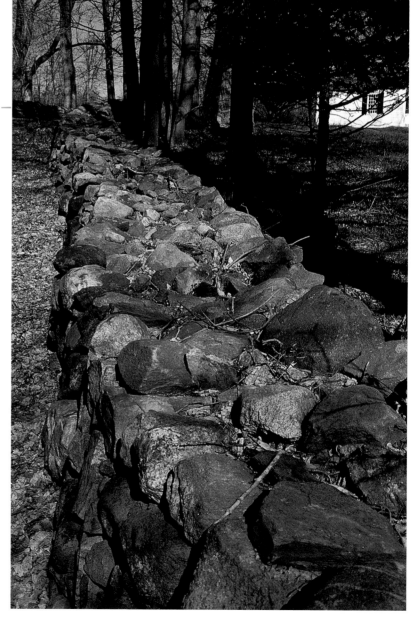

As opposed to the single stack, this **double stack** or **doubled faced wall** is considerably wider, made up of two parallel rows of larger stones with a filling of a variety of material in between. Many single stack walls became double walls as more and more rocks came to the surface to bedevil the farmer wanting a field easy to cultivate.

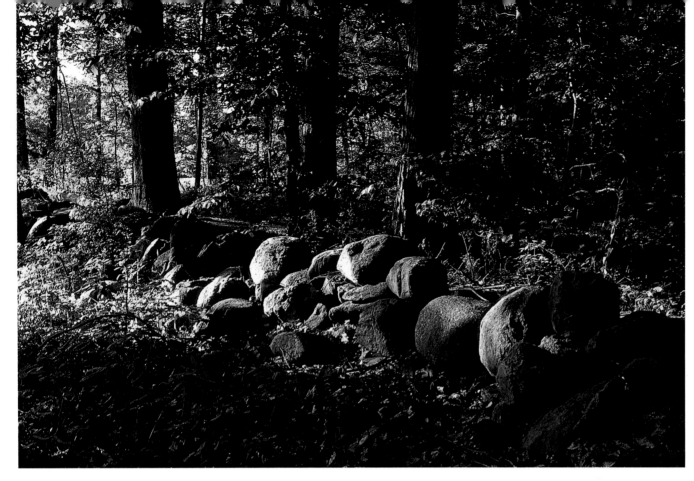

This unprepossessing row of stones in New Canaan, Connecticut, is actually part of the original **boundary wall** laid in 1686 between Stamford and Norwalk. As virgin land was developed, property lines had to be drawn and marked. It soon became apparent that the best markers were stone walls.

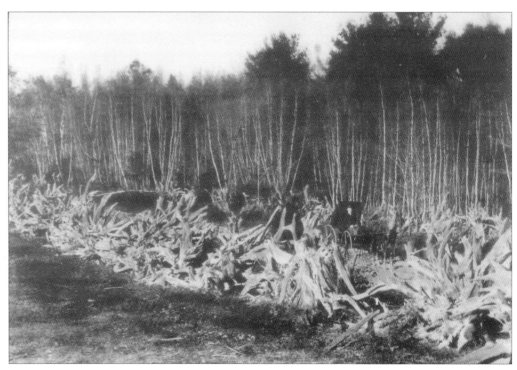

Often the first form of enclosure around newly cleared land, the **stump fence** was an efficient use of available material. This nineteenth-century version probably had its gaps filled with brush and other debris. However, it wasn't long before the stumps rotted and more permanent material was needed. Stones were a logical choice.

After the stump fence began to rot away, it needed to be replaced. From records of the time, these barriers generally were not made of stone, but wood. Wood was much easier to work with and very plentiful. The most common wood fence was called a **zig-zag fence**, also known as a worm, or Virginia, or split-rail fence. According to an 1871 Agriculture Department report, zig-zag fencing made up sixty percent of America's fencing. Traditionally, they were made of ten-foot rails, ideally of chestnut or cedar. As the fields were worked, year after year, more and more rocks appeared that had to be put somewhere. And under the zig-zag fence was as good a place as any!

And thus was created this **zig-zag stone wall**. Each zig and each zag, not surprisingly, measures ten feet. Finding a wall like this today is a rare event. If the land along the zig-zag fence had remained under cultivation, once the wood had rotted away and stones began coming to the surface in great numbers, the farmers would have straightened out the wall line with the annual spring harvest of the winter-born stones. Only where fields were abandoned 150 to 200 years ago can the ghosts of the zig-zag fences, like the skeletons of ancient reptiles, still be found, deep in the woods, nearly buried under the forest's debris.

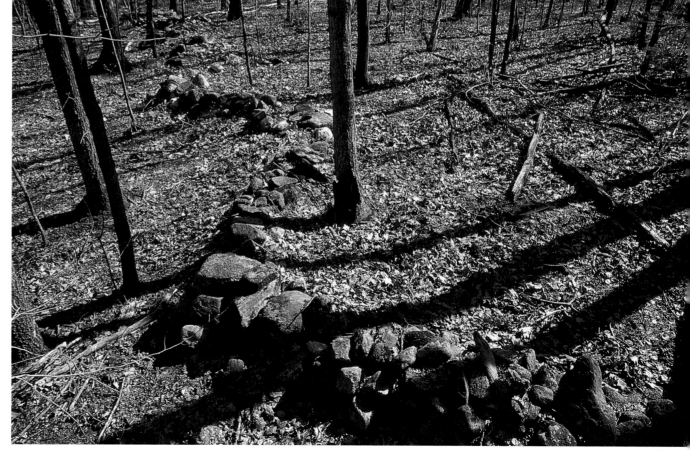

These walls, on a farm in Stonington, Connecticut, have changed little since the land was farmed in 1740 by David Miner, whose ancestors first cleared it in 1650. These typical single-stack **farmers' walls** were built as the seemingly endless procession of rocks rose to the surface each spring.

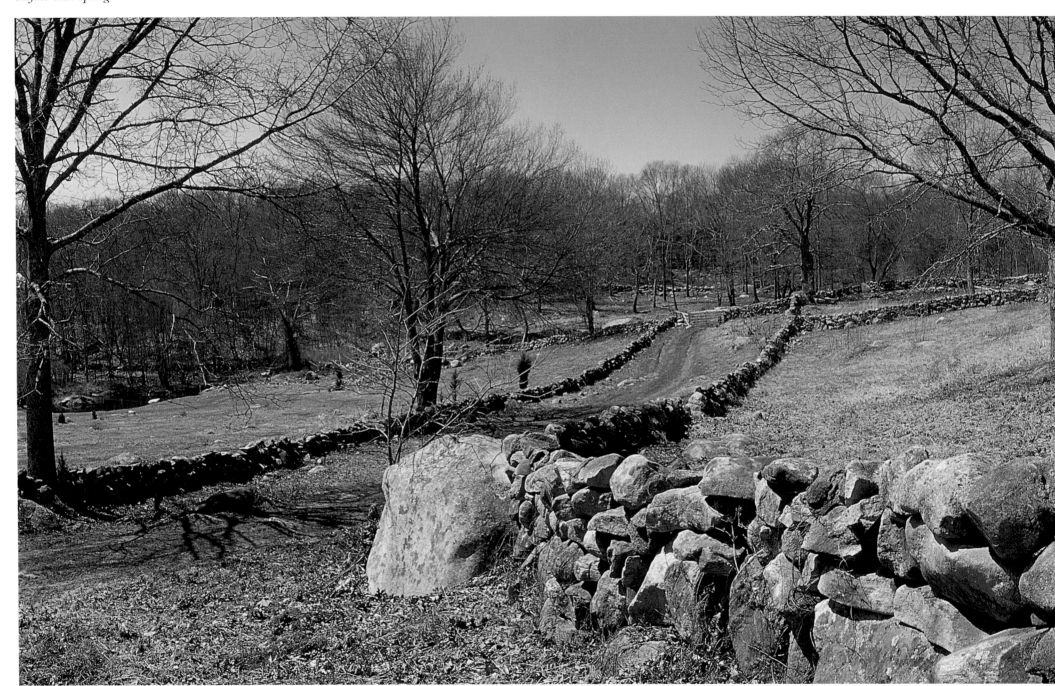

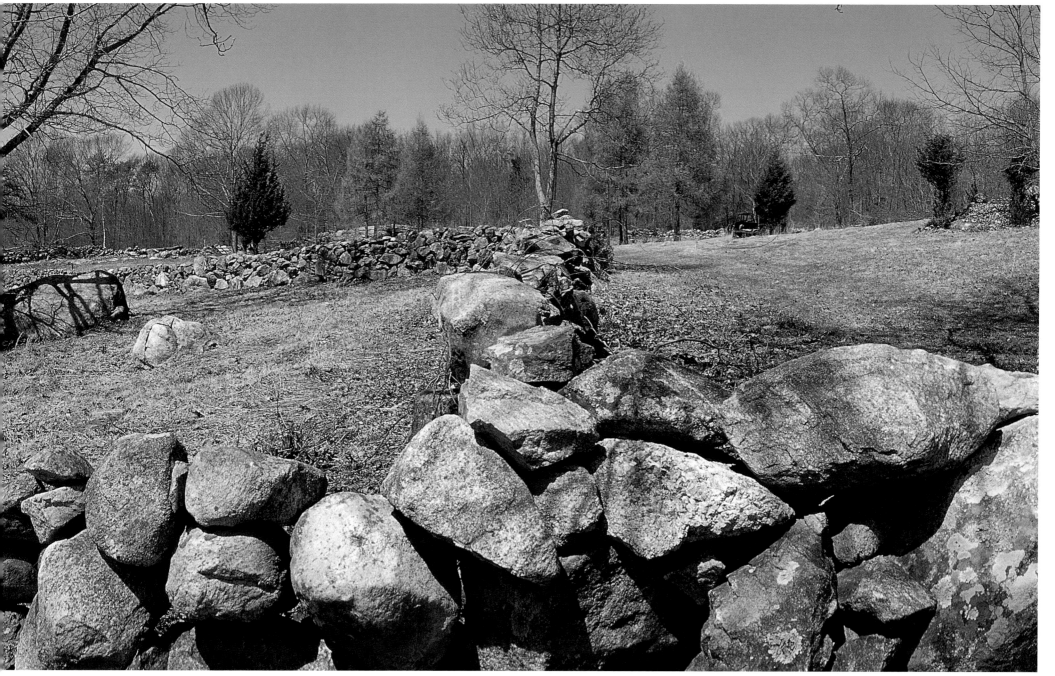

Granted that erosion has removed much topsoil over the centuries, nonetheless, one must stop and admire the courage and optimism of David Miner for having chosen this plot of land for his farm site. Amazingly, the farm remained in the same hardy family for ten generations.

How's this for an endless procession of rocks? On the Miner farm, bedrock—as you can see at the top of the picture—is revealed at the surface in places. Saving as much arable land as he could, this farmer dumped rocks too small to be useful onto the exposed granite. From their size, a root crop or vegetable garden must have existed nearby. Rocks this size would not have been a problem in pastureland.

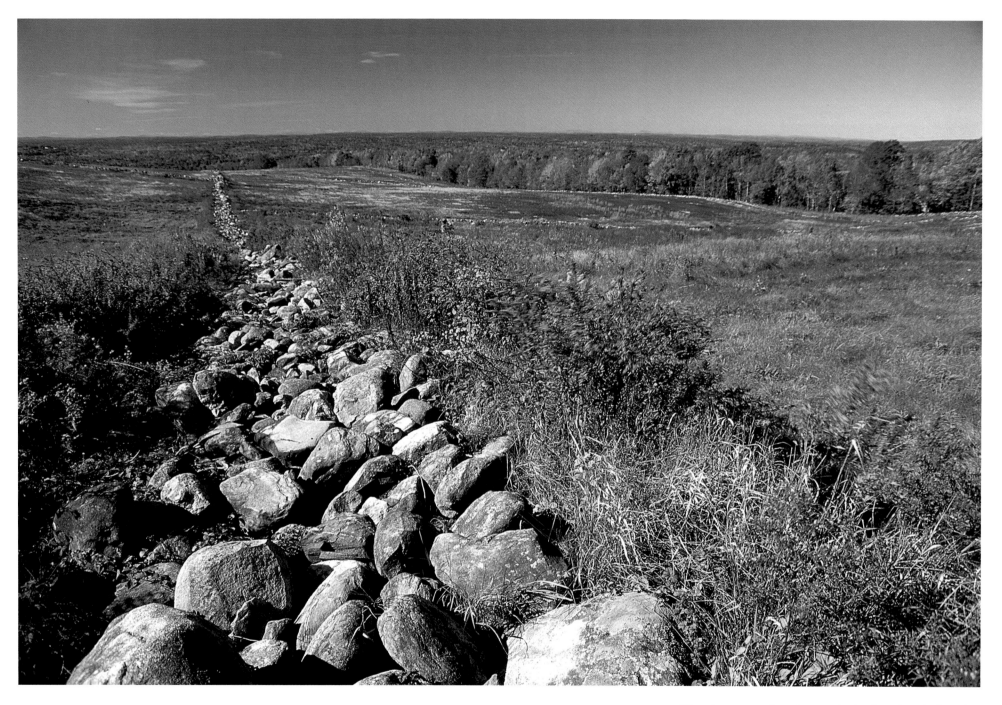

The pioneers, on first clearing the land, gathered all surface rocks and moved them to a convenient part of the field where they dumped them helter-skelter. So was born the **dumped**, or **tossed**, or **thrown wall**, or maybe simply "That #*#*#*# pile of #*#*# #*#*# rocks!" This wall was "built" in Dresden Mills, Maine.

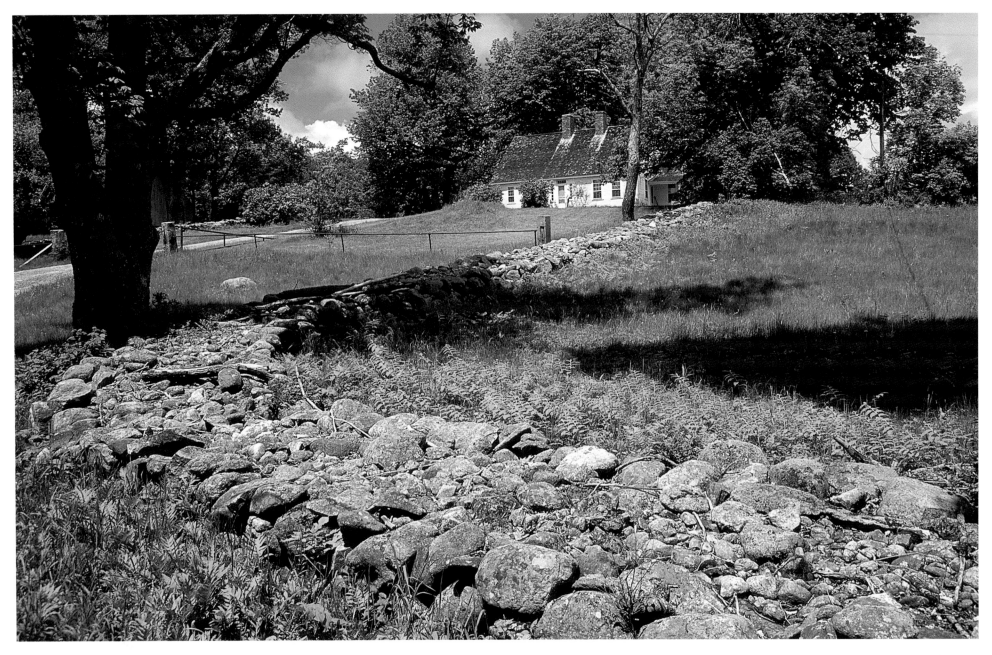

The **disposal wall**, *sometimes called a* **rubble wall**, *is similar to the double wall in that the outside gives a somewhat finished appearance, but it tends to be considerably lower and wider. A properly built double wall can easily reach five feet in height with a width of three to four feet. Height and stability are the goals. But the* disposal wall is built to present an attractive way of containing nature's rocky bounty. Rather than being placed carefully in the sandwich filling of the double wall, disposal wall fillings are just tossed in and, being low in profile, less effort is needed to get rid of the annoying rocks.

When walls were built on terrain which showed little promise for agriculture, odds are they were boundary walls such as this one in West Hartland, Connecticut, that runs between a swamp on the left and a steep, rock-encrusted hillside on the right. This is a substantial wall for what is now deep woods, standing four-and-a-half feet high and two-and-a-half feet wide. As early surveyors tended to lay out lines according to the cardinal compass points, walls running east-west and north-south may well have been built as property line markers.

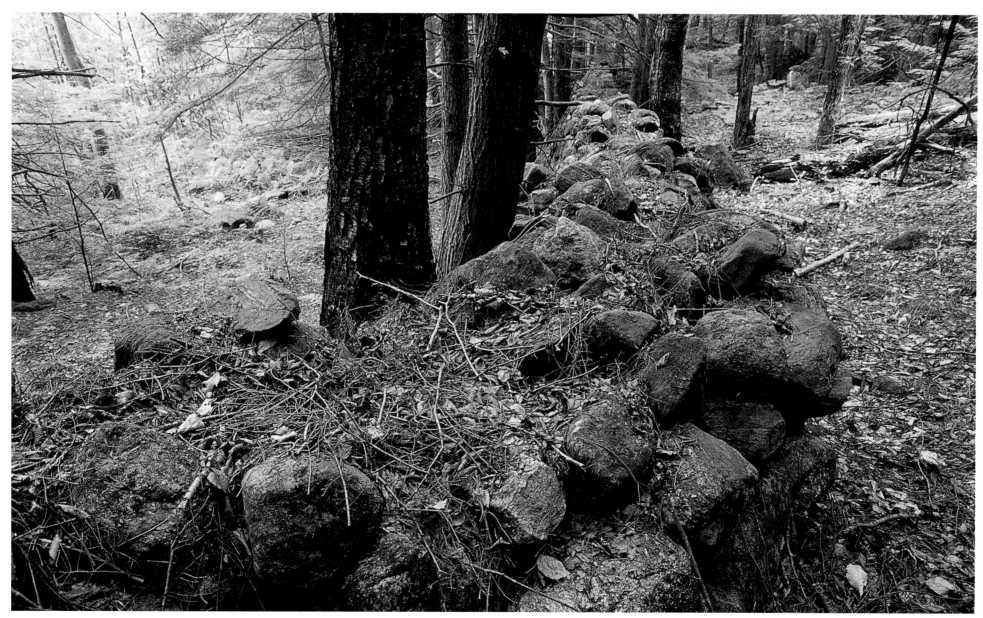

WALL BUILDER: TIM CURRIER

Tim Currier owns the Sticks & Stones Farm in Newtown, Connecticut. Located on a large section of steep hillside in a narrow valley, he farms rocks. "Yes!" he says, "rocks!" and one organic product—moss. Tim, a friendly bear of a man, is not at all bashful about his romance with stone. "How did I get started working with stone? Simple—just out of the love of doing stone. I just got involved with it and got attached."

Now a purist about drystone walls, Tim says he learned a lesson. "I started out being a drystone waller in the old style," he reminisces, "but then I had a period when I was sort of prostituting myself—throwing mud (concrete) in it—and in looks, doing what architects and landscapers were asking for. Now I've gone back to doing solely dry work. Keeping it simple. Keeping it native."

I was curious about his sense of the differences between new and old stone work. "Money. Money has changed a lot of things when it comes to stone walls. Today, walls are being built—they're sort of like money walls as opposed to utilitarian walls."

Tim believes strongly in using local material. "I guess I'm just such a purist about stone. If you're going to use it here, it really should be from here. I would guess that three-quarters of the stone sold to masons around here is not indigenous. A lot of it is brought in from Pennsylvania. It's not native. There's a big difference. I get my stone from this hillside. I don't get stone by taking apart other walls."

I asked him to define the difference between the classic New England drystone wall and a modern wet wall. "Walls are built differently now. It's not a stone at a time. It's a wall at a time, so to speak. Get 'em up and move on. They're just running these base stones on edge all the way down, do the other side and then just pour concrete down the middle. Then they come back and do another course. The homeowner just doesn't know the difference. Most of the people doing the stone work don't even know the difference. I'm not knocking them—it's just how they were taught. They just think square footage."

He continued, "The inner part of the wall is as important as the outer part of the wall, it's the heart of the wall. Most people think of the inner part of the wall as the rubble of the wall. That's definitely not the case with drystone work. The integrity of a drystone wall has to be throughout. There is nothing ostentatious about drywall, that's for sure. The

"I'm passionate about my work. I've found that, if you can maintain your passion, you never get worn out and you can keep your endurance up. Sure, you have your bad days, no question about that. I still lose my fingernails myself."

Pushing hard against this single stack wall, Tim shows how solid it is. His sharp eye caught the anomaly in this Weir Farm National Historic Site wall in Wilton, Connecticut: The larger stones have been placed closer to the top than the bottom. To Tim this signaled that this wall was laid up as the stones became available—they built with what they had. This wall has lasted in a top-heavy state for some two hundred years.

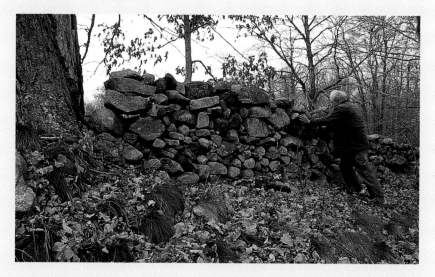

On his "stone farm," Tim and a friend sit by the shadowy stone remains of a worm (zig-zag) fence.

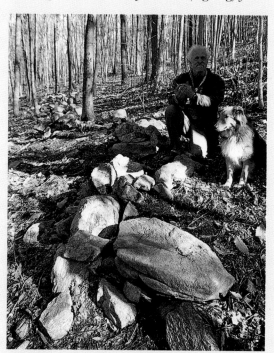

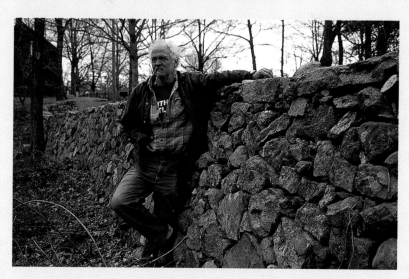

Tim Currier stands by one of the walls he rebuilt at the Weir Farm.

problem today is that not many people know how to build a drystone wall or are willing to spend the time. But when done properly, it won't fall over and it will outlast any wet wall. Unfortunately, you can't convince many people of that because they just think of the short term—getting the wall up fast and inexpensively."

Having spent so much time building walls, Tim has developed a philosophy to go along with his work. "Working with stone walls is a very meditative thing for me. When I first started out doing stone walls," he recalls, "I used to practice this mindfulness. I'd pick up stone after stone and just stay in the present. It created great peace of mind. You're just into the material and into each shape. (Here Tim's words come faster with real feeling and great enthusiasm). You're not getting sidetracked mixing and using cement. You're just using that pile of rock (pause) and turning it into stone (chuckle). If you find yourself getting annoyed, it will beat you up! It will hurt your back. It will hurt your fingers. But if you are at peace with it, it's the best."

The Wall-Building Explosion: 1750 to 1850

FRENZIED BUILDING AS MEN SETTLE THE LAND IN AN AGRICULTURAL AGE

Beginning in the the mid-1700s, population pressures in New England's coastal communities reached the point where young families had to move into the wilderness to make a life for themselves. As the Indian threat lessoned, and with a growing sense of self-reliance as the bonds to a centralized religious power grew weaker, moving out into the wildreness was less difficult. Since the rock-free bottomlands had been cleared long ago, the slopes and hilltops became the focus of the settlers' attention. As this new land came under cultivation, several developments greatly affected the construction of stone walls.

About this time a change in farming practices affected the dramatic growth of stone wall building. The shift from the European practice of common herding—where a community's livestock is pastured under the eyes of one herdsman—to the individual ownership of pastureland called for some sort of fencing. You guessed it: stone, home-grown stone, would help solve the fencing problem—as well as help solve the problem of what to do with it.

Within a generation, the seemingly endless supply of wood had begun to shrink. With the clearing of the hillside forest, the protective layer of mulch on the forest floor had eroded, thinning the insulating blanket that protected the deeper soils from the effects of the freeze and thaw cycle. This, combined with the absence of the protective root layer, caused the long-buried, glacially deposited rocks to work their way toward the surface. As the cold reached down from

above, it froze to the top of a rock and lifted it just a bit. Some soil slid into the void beneath so that when the next thaw came, the rock settled, but just a bit closer to the surface. It didn't take long for a once rock-free field to produce a new bumper crop of "New England potatoes."

The Revolutionary War brought a major disruption to the lives of colonists and eight years of severe hardship and sacrifice. Newly cleared fields, laboriously wrested from the primeval forest, became choked with weeds and saplings. With so many men at war, it was hard to find laborers to work the fields. Wooden fencing was burned for warmth. Many homesteads were abandoned.

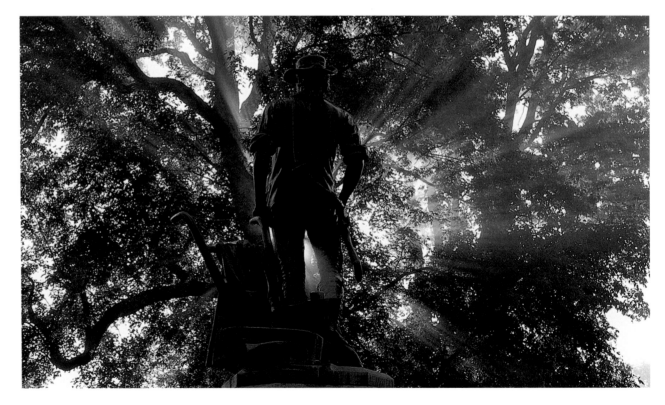

The Minute Man statue in Concord, Massachusetts, represents the citizen/soldier who left his fields and stone walls, shops and barns to fight for liberty and independence. It is believed that, during the war years, rural New England actually lost population and jobs.

After the war came a time of optimism and high spirits. Life settled down. An explosion in education, and in the founding of colleges, local libraries, and schools took place. Transportation links, vital to farmers living far from population centers, improved. As urban population pressures grew, the young moved out into the wilds and formed new communities.

As the population and the demand for farm goods blossomed, so did the need for farm fencing. The ample supply of wood which the original settlers used for their early fencing needs had long ago been consumed. Stones were the logical substitute—all too plentiful and wonderfully long lasting. During this period most of New England's stone walls were laid up—thousands and thousands of miles of them, built by farmers and slaves, Indians and farmhands, women and children.

But the good times were not to last. Inexpensive long distance transportation arrived with the opening of the Erie Canal in 1825 and the advent of rail transportation soon thereafter. This proved to be a double-edged sword. While in 1854, when fresh iced butter could be shipped from northern Vermont to Boston by train, trains were also carrying midwestern produce to Boston at a much lower price than New England farmers could afford to grow it. By 1860, Maine's wheat production had decreased by two-thirds due to western competition.

The railroads also made it vastly easier for people to travel to better opportunities. By 1850, it was reported that more than half of Vermont's native population had moved west. The urban centers of the east also drew thousands from the hilltop farms to manufacturing jobs and the amenities that the industrial

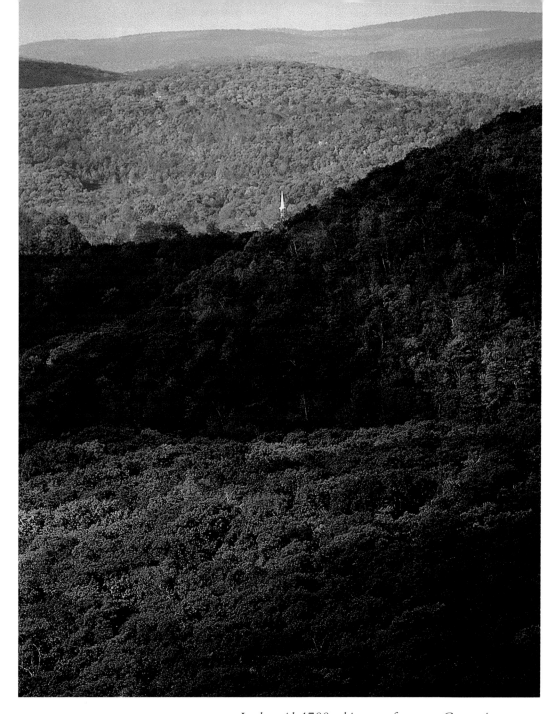

In the mid-1700s, this area of western Connecticut was as heavily forested as it is today, with only the glimpse of a steeple to indicate the colonial presence. By 1850 however, scarcely a tree could be seen. America's first iron foundries were located here. The trees were cut for the production of charcoal to fuel the foundry furnaces. Stone walls were soon built as farmers took advantage of the cleared land to pasture livestock.

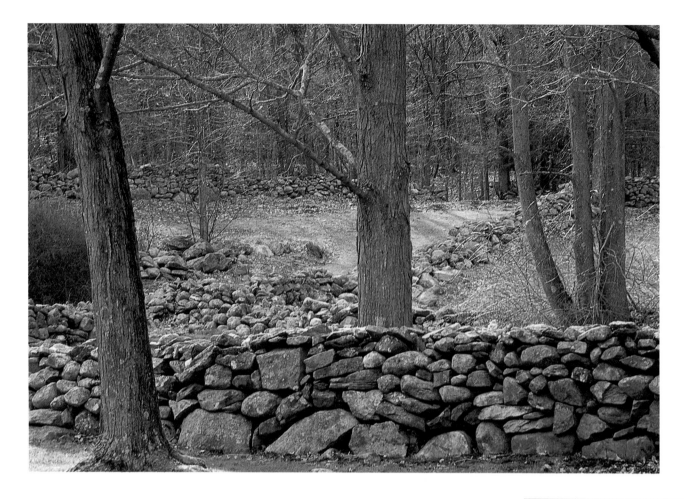

In 1811, the import of hitherto unavailable long-staple Merino sheep started "sheep mania," which became the base for many rural economies for seventy-five years. These walls, in Roxbury, Connecticut, likely contained sheep that, statewide, numbered 250,000 by 1840. The stone wall-building mania flourished as well. Sheep, which are notorious climbers, needed to be fenced to keep predators out as well as them in. Before barbed wire—and after the woods had been decimated—the stone wall was the logical choice to keep the animals safe.

This Harvard diorama depicts the land as it might have looked ninety years after the image shown on page 22. The farm's surrounding hillsides have been clear-cut and converted to pasture. Stone walls have replaced wooden fencing. Roads, so important in getting produce to market, are now evident. The subsistence farm has gone commercial.

revolution created. In the mid-1800s, farmland covered three-fourths of Connecticut. Today, barely one-sixth remains as farmland while two-thirds has grown back into forest land. The first steps on the road to the abandonment of thousands of small New England farms had been taken. Their ever faithful stone walls would soon be all that remained to remind us of the valiant battles fought by families to wrest a place for themselves out of the wilderness.

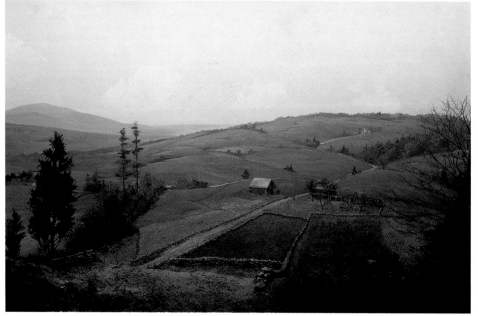

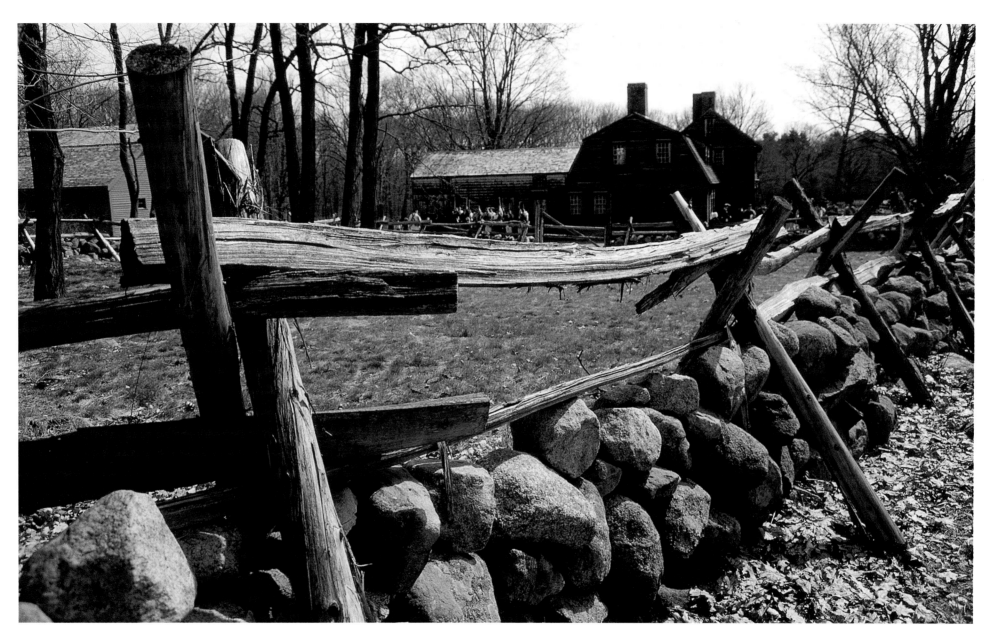

Compound walls *are those built of more than one material. Generally, the base is made of stone, three to three-and-a-half feet high—the maximum height a heavy stone can be lifted comfortably. To bring the wall to the required legal colonial height—usually four feet or more—other material was added which generally consisted of wooden rails, although almost anything* *would do. This wall, topped with a crotch fence and rail, can be found on the road between Lexington and Concord where, as Longfellow wrote in his poem "The Midnight Ride of Paul Revere," ". . . the British Regulars fired and fled / how the farmers gave them ball for ball / from behind each fence and barnyard wall. . . ."*

Finding a **capstone wall** *(or* **hard cap wall***) like this, especially along a dirt road in western Connecticut, is rare. Capstones are much sought after for their finished look, being both flat and the same width as the wall. They also protect the wall by keeping out debris, rain, and snow. But as they are the top layer, capstones have a way of being stolen away in the dark of night.*

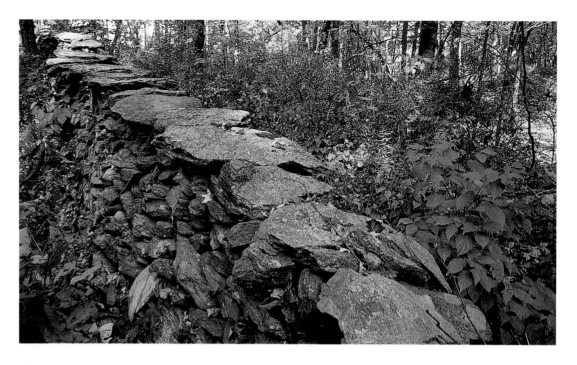

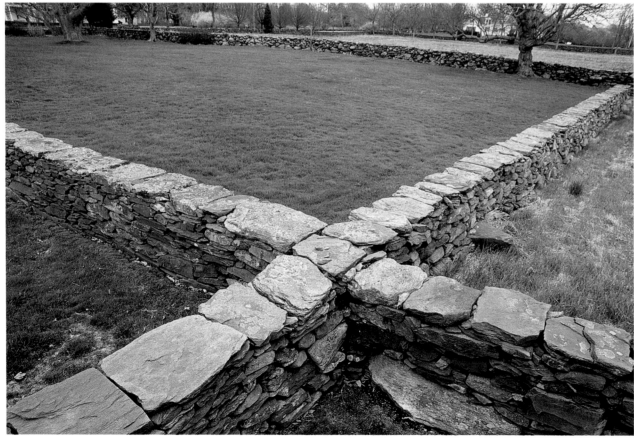

Fortunate indeed were the farmers in the Little Compton area of Rhode Island, where local stone is made of tough schists and quartzite which fracture into square-sided, easily handled plates, making a wonderful hard cap wall.

*A **lace wall**? An oxymoron? Hunky male stone walls and delicate, feminine lace walls don't seem to fit together under the category of stone walls. But, in actuality, they do. They are made of the same material but create a very different effect. Lace walls can be found all over New England, but the most renowned were build on Martha's Vineyard.*

A lace wall is a single stack wall, generally only one stone wide, that tapers upward as the stones get smaller. The airy gaps between the stones create its lacy appearance. This wall is located in the town of Chilmark, on Martha's Vineyard. As in many other New England towns, it is protected by a zoning ordinance.

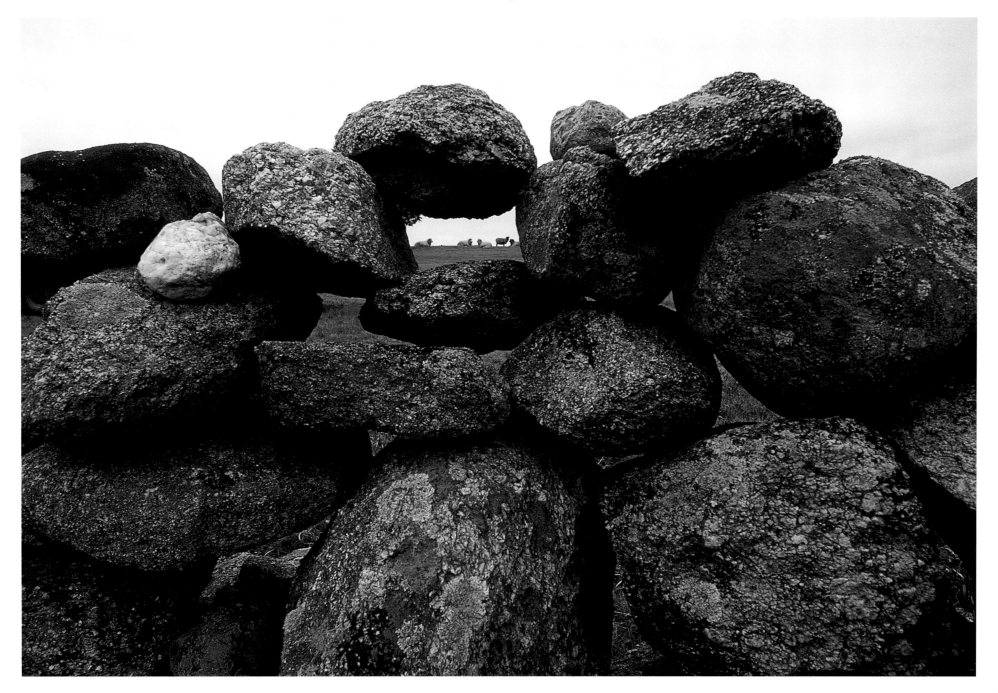

Lace walls were common on Martha's Vineyard for several reasons. As the land consisted entirely of glacial moraine, there was no bedrock to quarry and there were too few trees for wood fencing. The stones available were very hard and rounded, having survived the long, punishing, grinding glacial sleigh ride to the brink of the Atlantic.

Consequently, walls were erected of whatever round, water-washed stones were available, some of which could be stacked as high as four feet. Secondly, the farmers, who mostly raised sheep, found that the airiness of the walls made the animals think twice before clambering up them. A third reason might be less obvious—the wind. On an open island exposed to fierce Atlantic gales, the laciness of the walls gives the wind free passage.

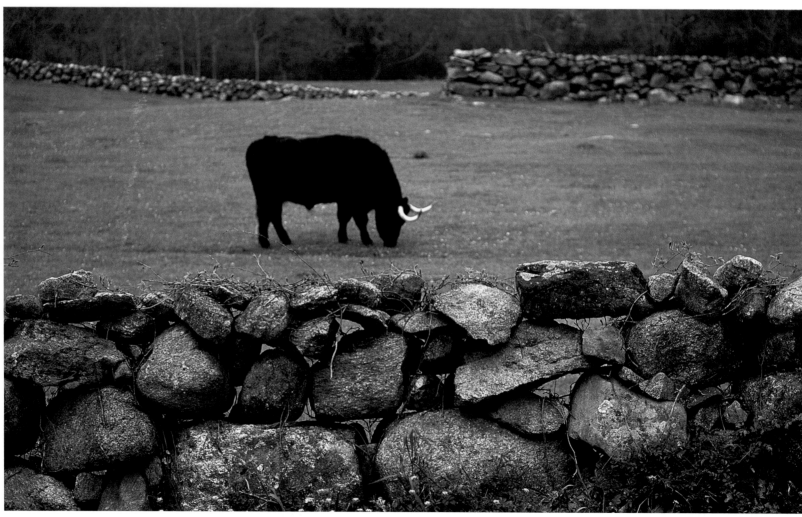

Bedrock walls *are those that cross solid bedrock. This solves the problem of dealing with frost heaving, but a real problem arises if the wall crosses a slanted section of rock. Over time, gravity will pull it downhill. Wallers found they had to drive iron pegs into the bedrock to stabilize the whole effort. This wall crests a high hill in western Maine and is unlike any I've seen elsewhere. Its low stature and remoteness from other human activity and arable land seems to indicate that it was built as a boundary wall.*

Retaining walls, *like this one in Warner, New Hampshire, are like foundation walls except that their faces are meant to be viewed from the outside, not from the inside of a cellar. Nevertheless, both are built with the same principal in mind: to withstand the great pressures of dirt, rocks, and moisture that tend to slide into a void.*

41

In 1827, when two brothers found themselves living side by side on a muddy dirt road in Hardwick, Massachusetts, they decided to build themselves a wall. As an article about the wall in The New England Homestead of 1937 gushed, ". . . there is scarcely a stone that so much as rocks and the most delicate of females could walk the length of the wall (four hundred feet) in her thinnest slippers without danger of stubbing her dainty toes or having vapors from the pain of a turned ankle," as represented by this ghostly image. The "Brothers' Walk" was so well "laid up" that it remains as solid today as when it was built 175 years ago. Three feet wide and four feet high, its surface stones vary in length from 18 to 72 inches. Now that's a hard cap wall!

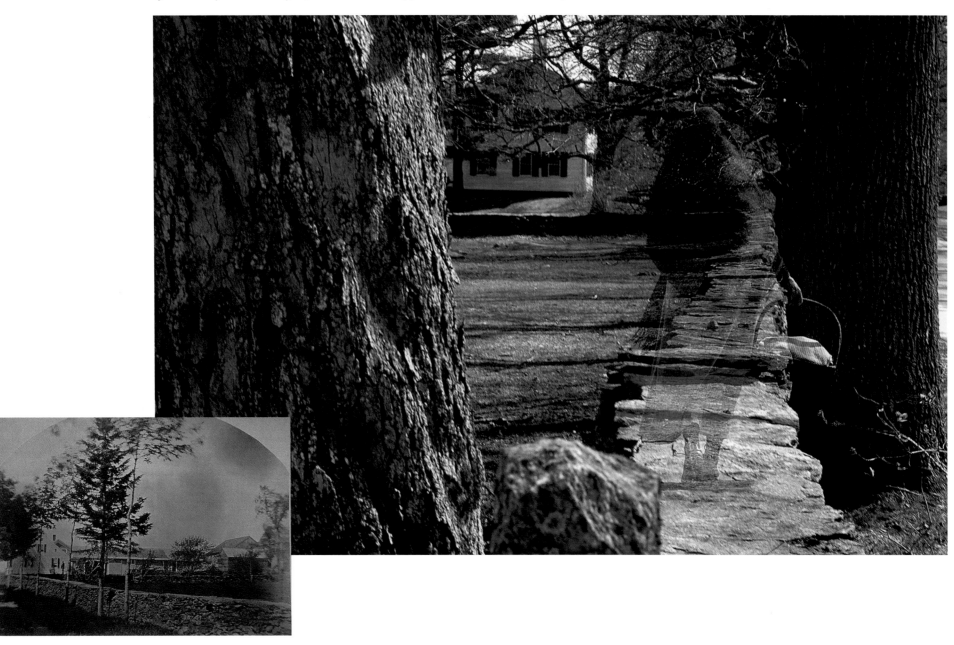

The "Brothers' Walk" circa 1870.

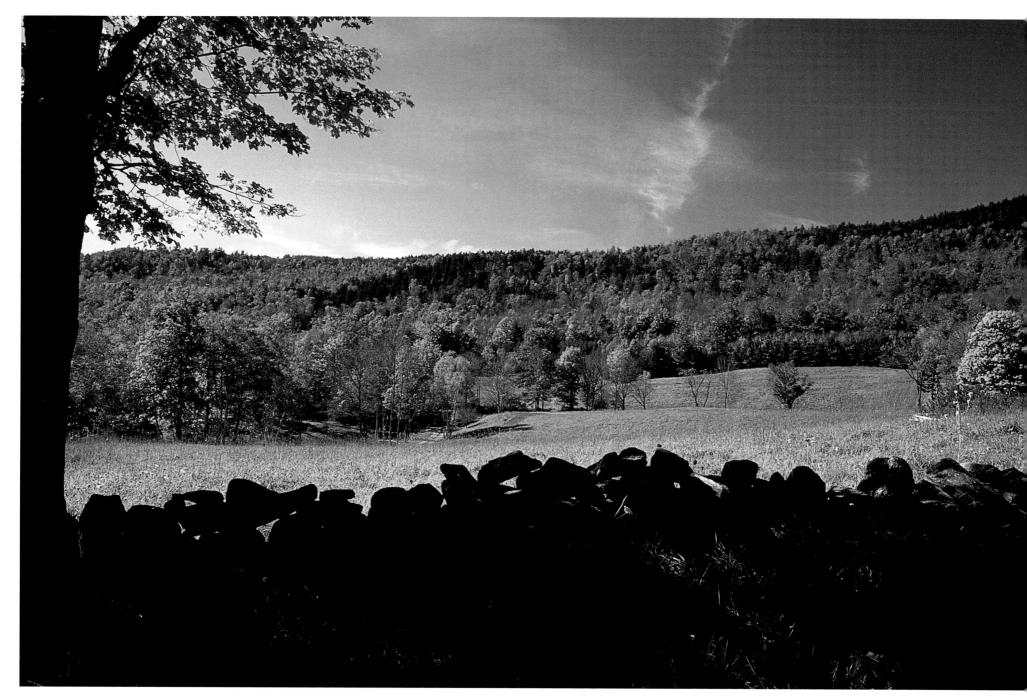

Lace walls are found not only on Martha's Vineyard, but throughout New England. This wall, outside Woodstock, Vermont, was built to the typical height of three feet, about the maximum height for one man to easily lift a heavy stone. A higher wall usually requires two people, a ramp, or some kind of lifting aid.

The builder of this wall in Brooklyn, Connecticut used **saddle stones** *to raise the height of the wall's wooden poles, a much more practical and economical method than building a crotch fence (see page 37).*

(see page 37)

One of the surest ways to distinguish an authentic colonial house from a replica is to check the **foundation**. *The authentic colonial's foundation will have been formed of handmade brick or stone, sometimes blocks of quarried granite weighing tons. This granite-supported Maine house was built in 1845. A replica house is built on a foundation of concrete, brick, or cinder block. In most areas, new stone foundations do not meet modern building codes.*

The Battle Road, between Lexington and Concord, Massachusetts, runs largely along the same route it did on April 19th, 1775. Every year a re-creation of that battle is held. Because, until recently, the road was a modern paved highway, the walls along it have been re-created as well. In their newness, they look as if the farmer and his team of oxen had just wrenched them from the soil. Most are still free of lichen and moss.

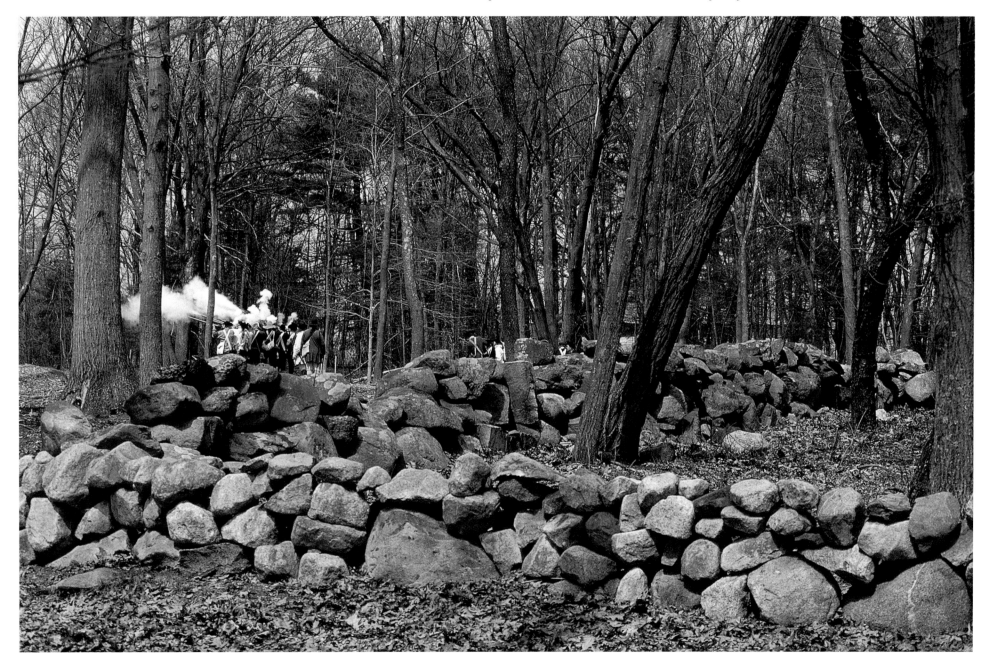

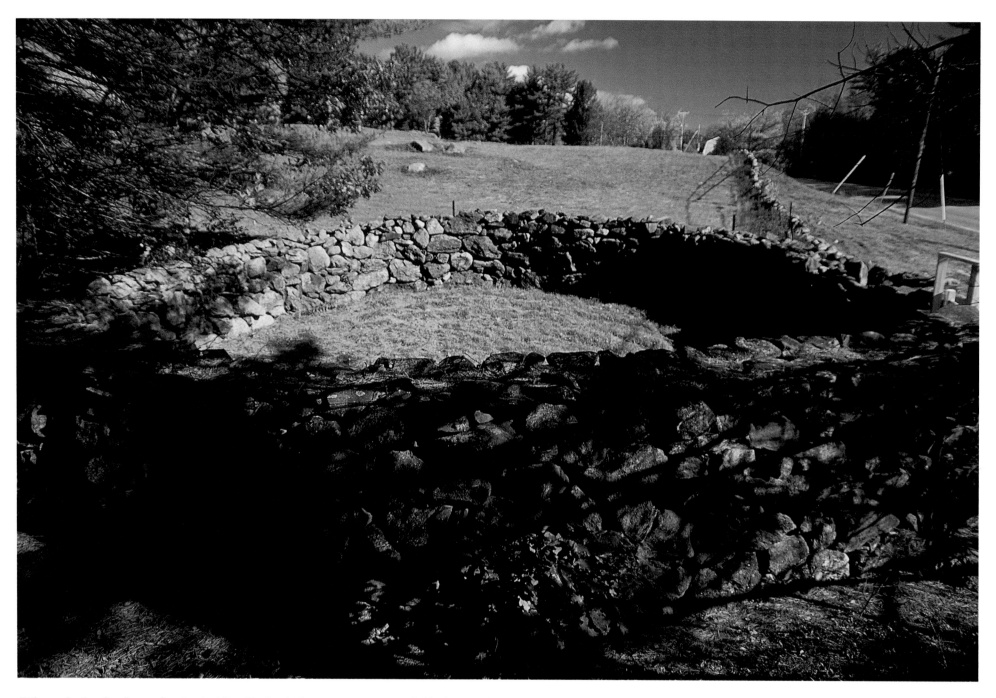

When colonists first began farming in New England, their livestock was kept on unfenced, common land tended by herdsmen and shepherds, as had been the custom for centuries in Great Britain. Should an animal stray and end up in a cornfield, the irate farmer would drag the wayward beast to the **pound**, or animal jail, where it would remain until bailed out by the fine-paying owner. This unusually round pound was found in Milton, New Hampshire.

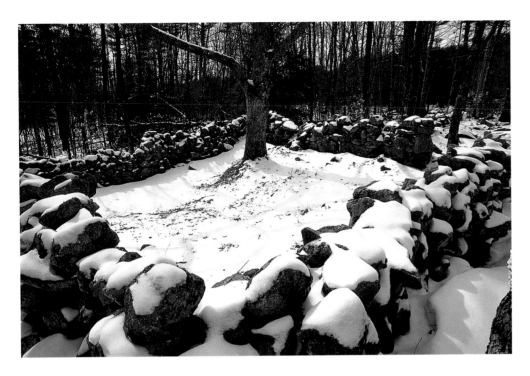

A resident living next to this pound told me with some degree of resigned pride, "Yup, Porter is the rockiest place in Maine. But, you know, there is something so peaceful about stone walls." Pounds varied in size and style, but were built usually of stone with walls five to six feet high set some thirty feet apart. This pound, located on a backwoods dirt road, is bare bones, made with glacially rounded stone straight from the field, not fancied up in any way.

Hillsboro Center, New Hampshire, a quintessentially unspoiled New England village, maintains a pound that meets the same description. As the colonial population increased and land for private ownership became available, communal agriculture broke down. Town pounds, however, remained fixtures of rural life right into the twentieth century.

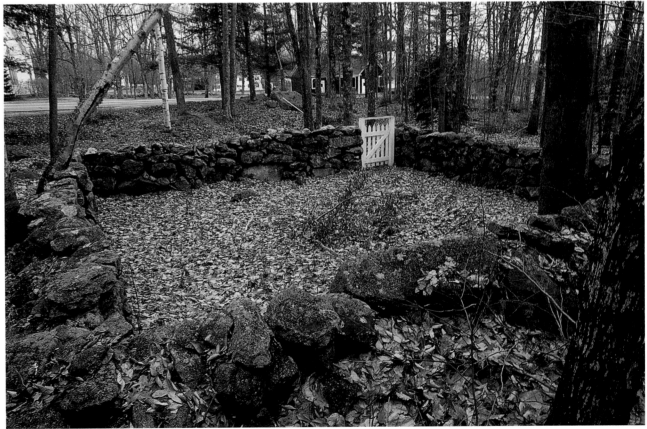

Typical of most, this Auburn, New Hampshire, pound was built in 1842 along a main thoroughfare near the town's center. This facilitated moving a wandering animal to the lockup with as little inconvenience as possible.

While this Durham, New Hampshire, pound has been rebuilt several times since its original construction in 1709, its sheer bulk and authority proclaim, "Don't mess with me!" Pounds that survive today do so thanks to either their massive construction or to the pride of the local citizens for their agricultural heritage.

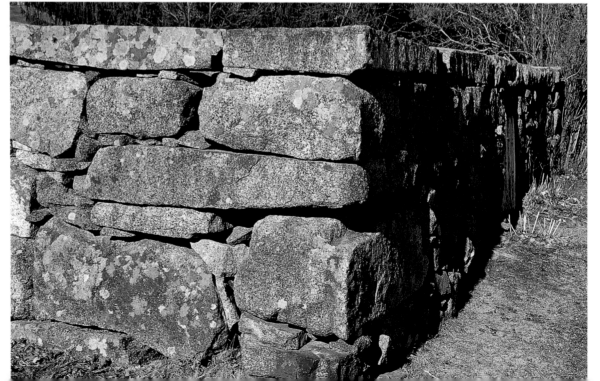

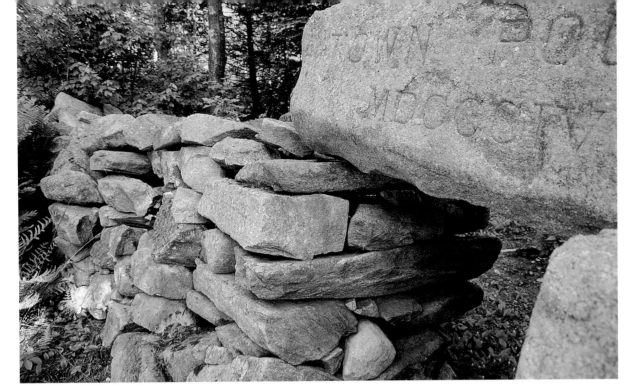

The Chester, New Hampshire, pound dates back to 1804, as the uncut stone lintel proclaims. By the start of the twentieth century, town pounds had outlived their purpose. Many had either faded from sight—forgotten in the weeds and roadside brush—or had begun to be dismantled, serving as a ready supply of easily accessed building stone.

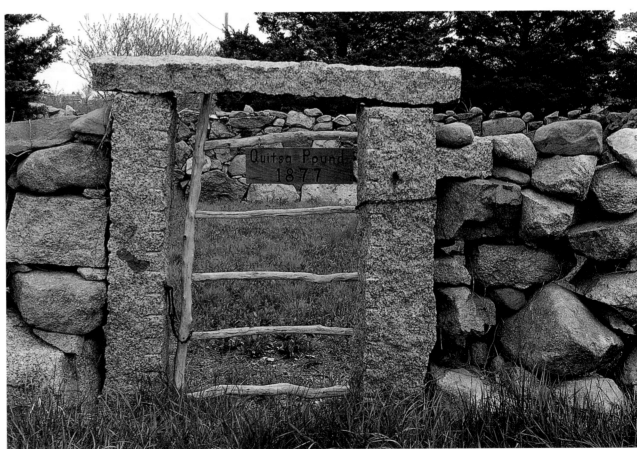

This pound on Martha's Vineyard, constructed primarily of common fieldstone, was built where sheep farming is still a business. The gateway frame, however, was created from quarried stone, either imported or cut from glacial erratics, as there is no bedrock on the island.

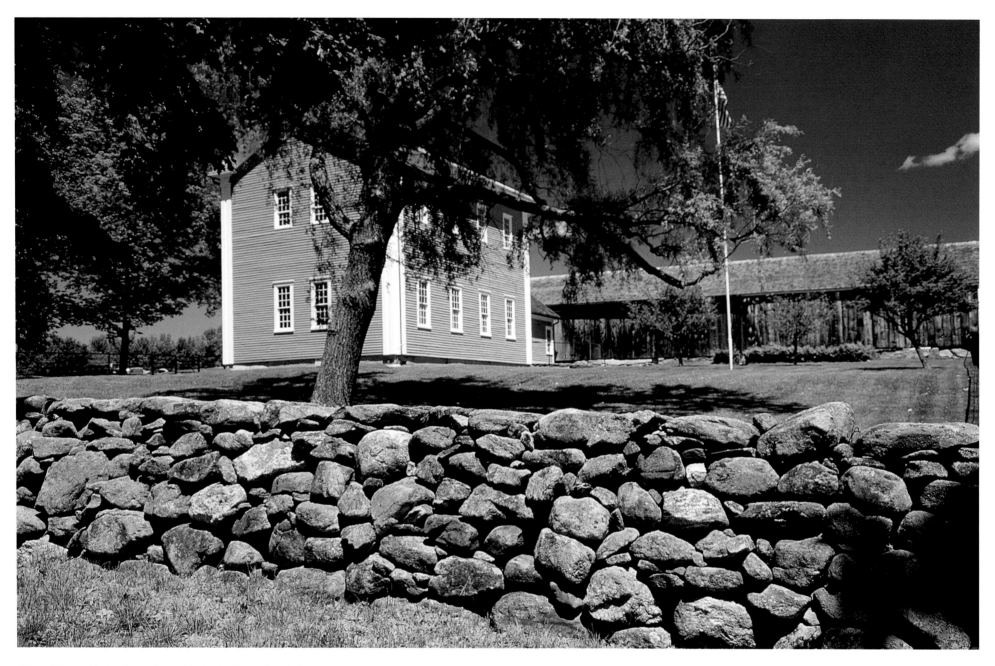

New Hampshire's Canterbury Shaker Village, founded
in 1792, grew and prospered. Convinced that hard work,
simplicity, and orderliness were necessary for living a fully
spiritual life, members of this religious community worked
with a passion. Seeking to create a heaven on earth, they
felt that laying up beautiful stone walls helped in creating
a heavenly order.

The earliest Shaker wall is presumed to be this one, just south of the village. It was begun around 1797 with rock cut from boulders uncovered while clearing the land for agriculture.

Parts of some Shaker walls are built of "one-handers," stones a waller can lift with one hand. Local lore has it that these were laid up by a very talented craftsman who lost two fingers to a circular saw (which some Shakers claim he invented).

While the front side of the wall is beautifully fit together, the hidden backside is packed with other rocks that had to be cleared from the fields. The best place to get rid of them was along the old wall line.

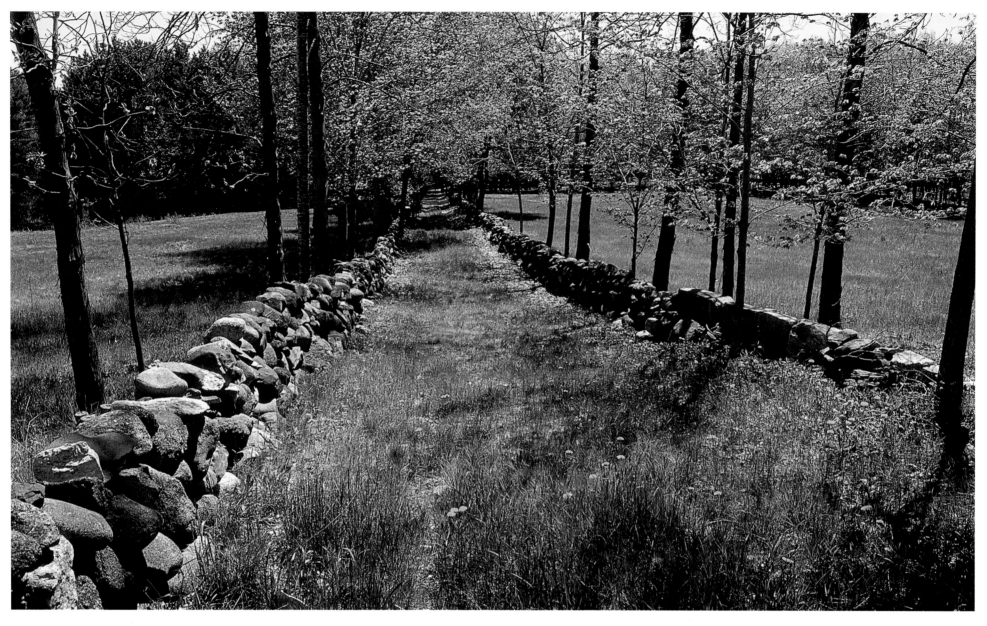

They can be found all over New England. They come under various names, but all serve the same purpose. "Lane way" in Rhode Island is one; "cow run" in New Hampshire another; cattle way, cattle guide, cattle run. Comprised of two parallel stone walls, they generally lead from an old barn foundation out into fields—or to where fields once had been. Imagine a barefoot, towheaded ten-year-old, with a birch branch whip, guiding the milk cows out to pasture on a dewy spring morning, and doing his best to avoid the cow chips underfoot.

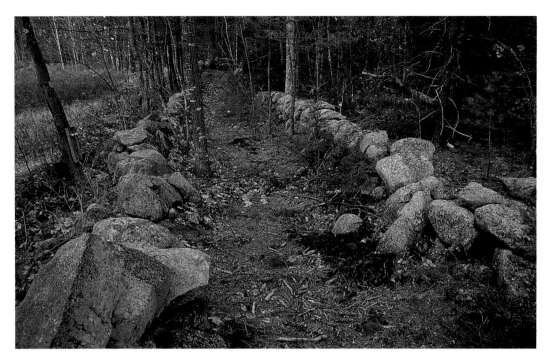

Some cattle ways are primitive and narrow, like this one on Stewarts Peak in Warner, New Hampshire.

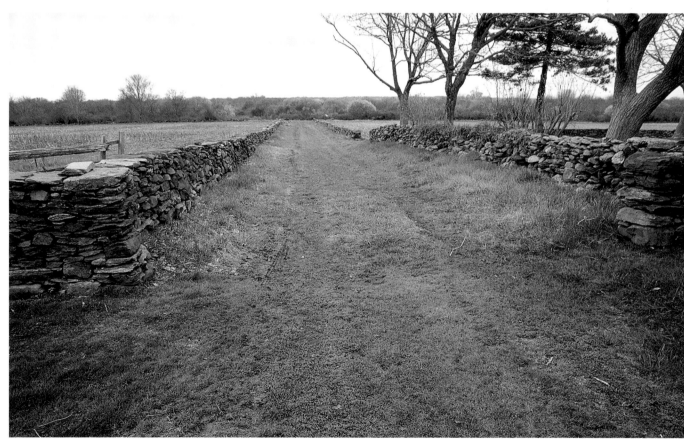

Others are more grand and spacious. This example, called a lane way in Little Compton, Rhode Island, serves both as a channel for livestock and as access to the fields for wheeled vehicles.

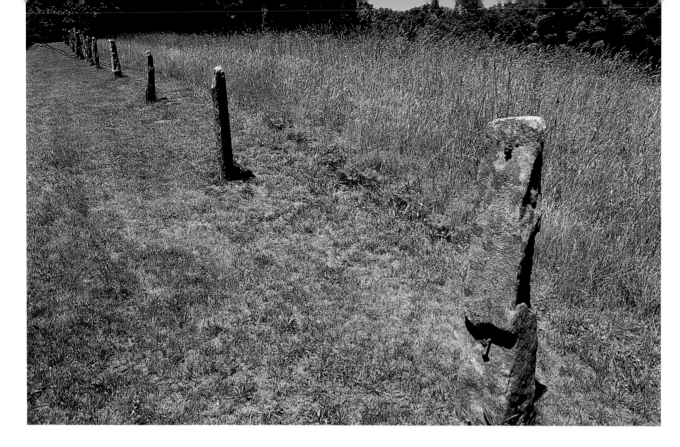

Resembling Easter Island statues, these granite posts in Higganum, Connecticut, don't make up a stone wall, but they made excellent supports for attaching a wood fence outside a small brick building that was originally a rifle factory built for the War of 1812.

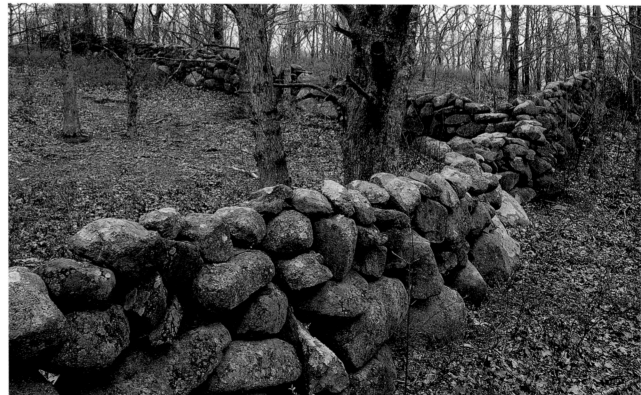

Another view of a a single stack lace wall, more crusty with lichens than lacy. These weird growths, part fungi and part algae, might help in dating the age of a stone wall. The crustose lichen, which grows flush with the rock like a smear of paint, grows about one millimeter a year. A lichen with a radius of twenty-five millimeters (or one inch) would be around twenty-five years in age. One would need to be sure, however, that the lichen wasn't already growing when the stone was placed on the wall!

In Sermons in Stone, *Susan Allport writes about an unusual wall. Located in Westminster, Massachusetts, it has been called the "spite wall." The story goes that hard-working farmer Edmund Proctor, contrary to the social norm of the day, liked to work on the Sabbath. To keep nosy neighbors from spying on this breach of etiquette, he surrounded his field with an eleven-foot-high wall, not much of which remains today.*

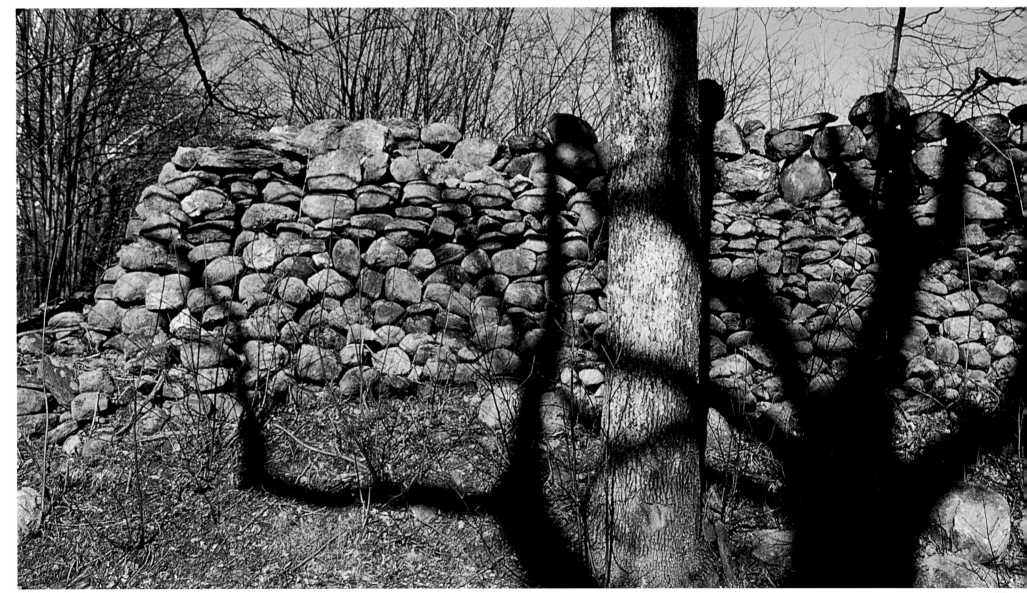

One occasionally meets mysteries in the New England woods, such as this wall discovered in Bridgewater, Connecticut. The well-finished butt end (a difficult wall structure to build) rises five feet high at the upper left. It marks the end of a wall that runs some fifty yards into the woods. One sees, however, no sign of it having ever been part of a structure. On the right a much more crudely built wall rises to meet it.

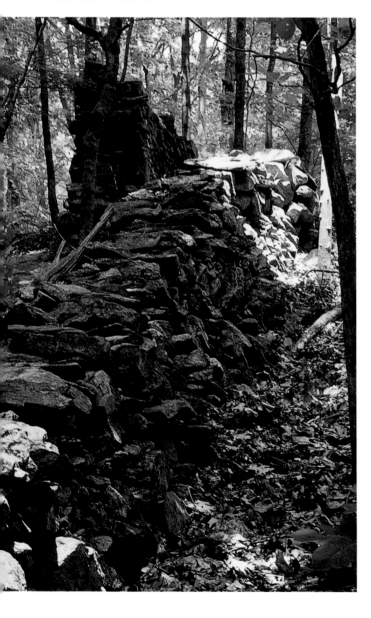

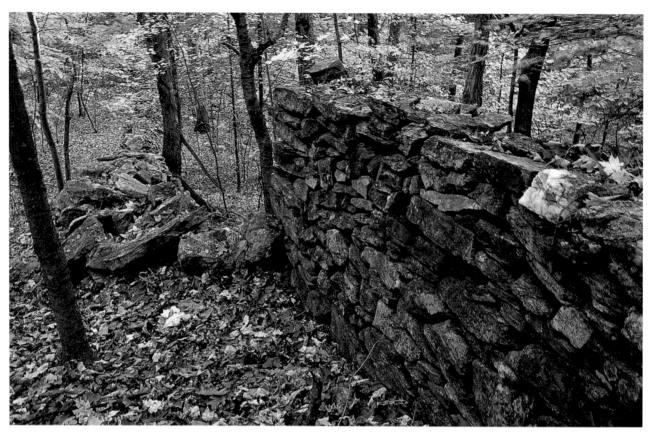

For eternity the twain shall never meet. We may never know the reasons for the discontinuity or the height differential. But another question raised by the walls on this hillside did get answered. I noticed that they were spaced apart at regular intervals. I measured five that were almost exactly 400 feet apart. Why 400 feet? I learned that the common linear measuring device for the colonial surveyor was the Gunter's Chain, 66-feet long and made up of 100 links. (A mile is 5,280 feet, or 80 Gunter's Chains). Six Gunter's Chains come to just four feet shy of 400 feet, so it seems probable that the chain was used to lay out these former fields in a neat and orderly fashion.

I've often wished walls could tell their stories—and sometimes they do. I came across a 1923 newspaper article about this wall in Falmouth Foreside, Maine: "Every child who has lived near what is now called Skillins Corner has run barefoot the length of the last named wall. Every pair of lovers within a mile or more has plighted vows and sworn undying affection either seated on its rocky surface or behind its sheltering shade. Very few people know or realize that this wall has a history. It was built or laid up by Negro slaves owned by the Bucknam family." Slaves built walls in many other New England states as well, including Rhode Island and Connecticut, before the Revolutionary War.

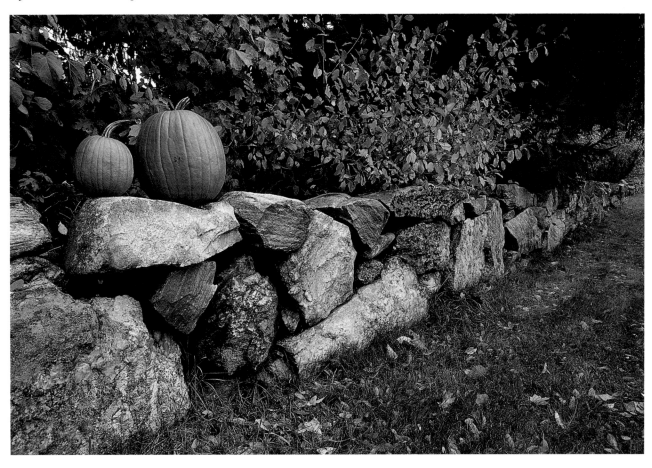

In the Minks Hills of Warner, New Hampshire, one may find many interesting walls. This one speaks to the monumental frustration the continual appearance of rocks must have caused the farmer. He not only had to build the first wall of larger rocks on the left as he prepared the land, but then he nearly doubled its width with smaller stones over time as the annual freeze and thaw cycle brought more to the surface. By their small size and by the plot's location directly across the road from an old farmstead, this wall may well have surrounded a vegetable garden.

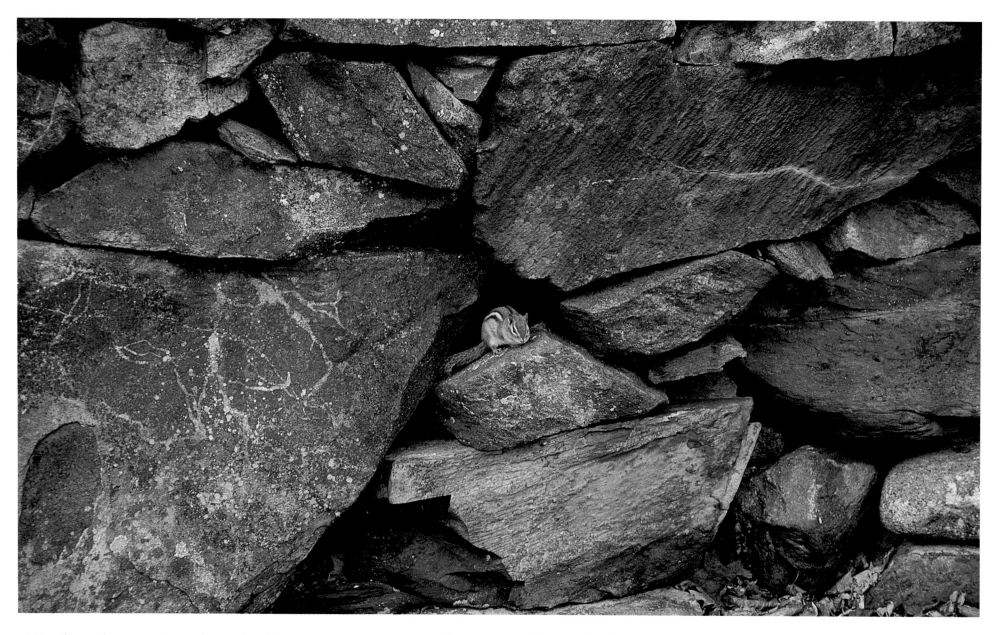

A tiny chipmunk on a massive cattle pound wall in West Lebanon, Maine, is symbolic of a vital ecological fact: Stone walls have been in place in New England for centuries—long enough to become completely intertwined with the processes of their environment. These man-made constructions, intentionally built to serve their builders, now serve man and nature equally. They provide habitat for countless small animals, which, in turn, provide unwilling meals for countless larger animals and birds. The walls reduce erosion and change drainage patterns. They create a greater variety of microclimates for living things than would ever have been possible without them.

In Bantam, Connecticut, I came across an interesting stone wall masquerading as a split-rail fence. It was built in front of a house dating back to the 1700s which was once a tavern and stage stop. The story goes that the stone cutter who built the wall had run up a large tab at the tavern. Building the wall paid off his debt.

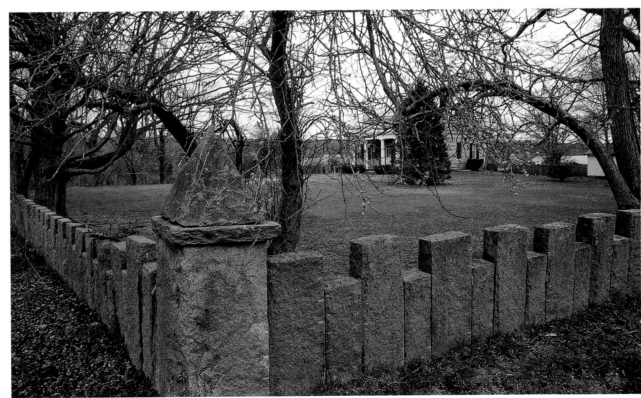

A most unusual cut stone, crenelated wall sets off this property from the road in Westport, Massachusetts. The stone house with eighteen-inch-thick walls was built for sea captain Stephen Howland around 1793.

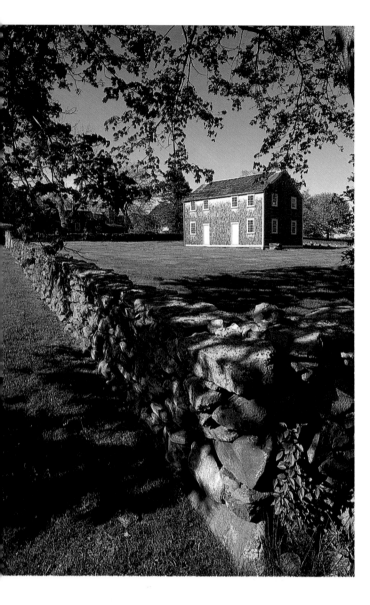

The Friends Meeting House in Little Compton, Rhode Island, was originally built in 1700, but the date of its fine **laid wall** is unknown. A laid wall can be defined as one that has gone beyond the purely stone storage state to one having architectural merit. (For excellent definitions of wall classifications, check Robert Thorson's book, Exploring Stone Walls.) Early photographs show it in this location, designed to keep farm animals being driven to market from wandering onto the property.

Little Compton was settled in the latter part of the seventeenth century by former members of the Plymouth Colony. This wall and fields are part of the property settled by Elizabeth Alden Pabodie and her family in 1644. She was the first white child born in North America, the daughter of John and Priscilla Alden. The house where she died at age ninety-three still stands. It is said that at her death she left 12 children, 82 grandchildren, and 556 great-grandchildren. (That has nothing to do with stone walls; I just found it interesting.)

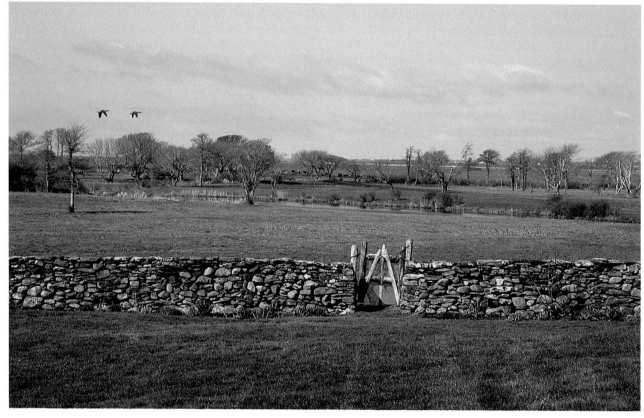

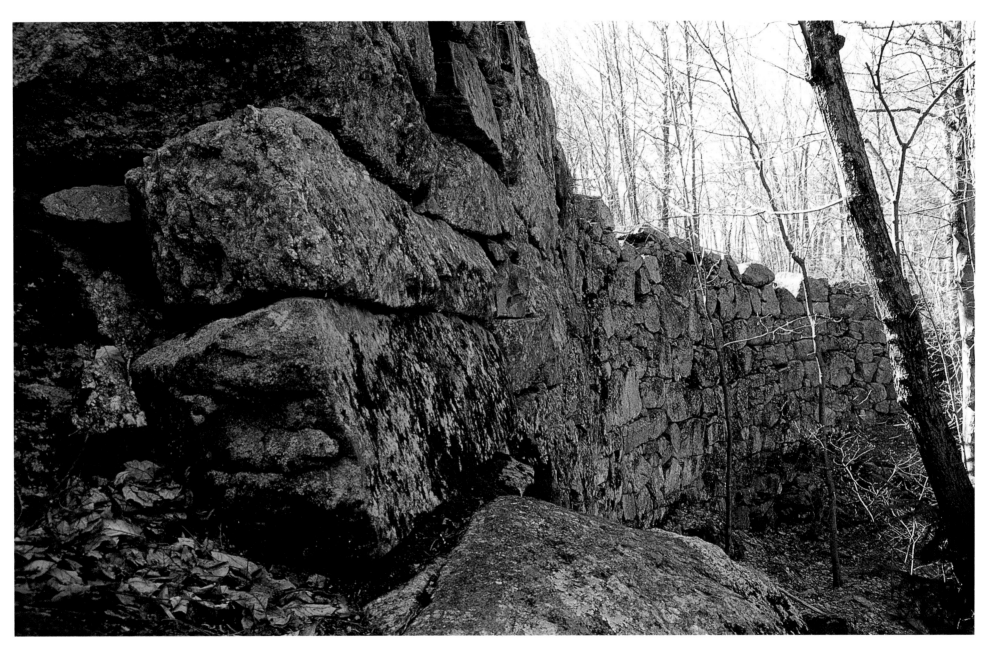

Dams certainly qualify as walls. This awesome example, some 25 feet high by 125 feet long in New Town, Connecticut, was erected around 1800, long before fossil-fueled machinery was available. Teamwork between oxen and men, plus some amazing engineering and excellent stonework, built this dam whose waterwheel supplied power to a saw- and a grist mill as well as to wool carding and cider mills.

Wall Builder: Michael Weitzner

When Michael Weitzner gives directions to his house, he provides a full page of instructions that detail the four miles from the interstate exit to his home, nestled against a wooded Vermont hillside just southwest of Brattleboro. Michael is as precise a wall builder as he is a wordsmith. In a voice that reflects the influences of a Swiss mother, an American father, and a number of years living in the British Isles, he explained what keeps a waller happy, "It's enjoying working with one's hands and body, and being comfortable doing hard work. And a creative streak of some sort, whether it be in the design or the placement of whatever the customer is looking for. An ability to stay with it, even when you're not feeling too great about it. Determination, I guess."

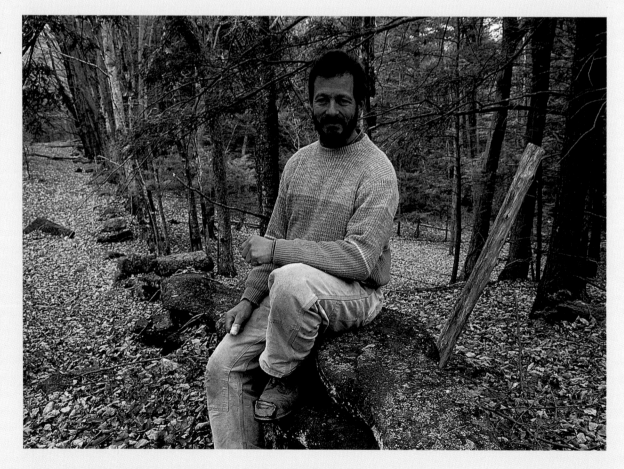

He also offers a waller's pragmatic advice, learned from years of experience. An important trait, he said, is "having an eye for stones that will fit. The vast majority of successful drystone wallers tend to pick up a stone and find a use for it; that's an important thing to learn as a waller . . . you don't want to have to put it back down again. That's work that you've wasted. If it doesn't go where you intend to use it, you try to put it elsewhere in the wall rather than back on the ground—that's especially easy if it's a retaining wall!"

We walked along an ancient road on his property on a dark November day. Pointing to the stones in a wall we were passing, he said, "These walls are probably from the middle of the nineteenth century. That was the peak time for sheep raising here in Vermont, about 1840 to 1870. These walls as we see them today are nowhere near tall enough to keep sheep in. Before barbed wire, some sort of wooden fencing might have been used to increase the height."

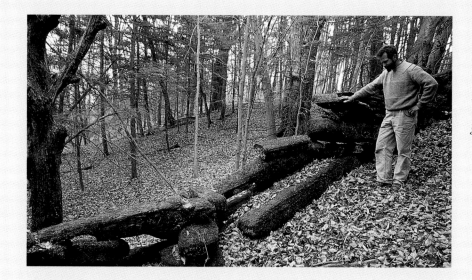

"The slabs at the base of this wall are set on edge, wedged into the soil. In Britain, that would be a no-no, but this is typical of this area where there is a lot of long, thin stone. The only way to use a stone like that without breaking it is with its length along the wall, even though it may be unstable. Ideally, you want maximum contact between stones inside the wall, with everything touching as much as possible. Placing stones with their length into the wall gives much better stability."

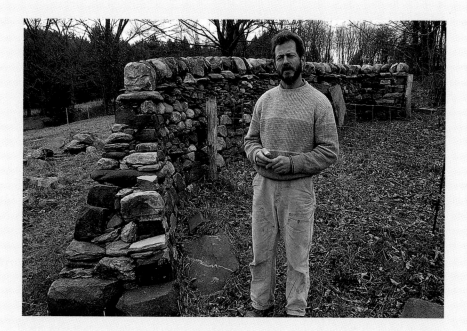

In the process of interviewing wallers, I found that they respect the forces of nature. I'd always thought that these walls were indestructible. "Not so," says Michael, pointing to the barest shadow of a wall and a rock pile here and there, fading into the forest duff. "If we came back in three or four, maybe five hundred years, there might be absolutely no trace of these stones on the surface. It's clear that, although walls have a sense of permanence in our thinking, because our lifetimes are relatively short, they last for generations in our time, but in the grand scheme of things, they are really very temporary structures."

Standing by a copestone-topped demonstration wall, which he built as a teaching tool, as well as part of his sheepfold, Michael explains his thoughts about why people are fascinated by the wall-building process. "When I tell people what I do, they say, 'Oh, what a wonderful thing to be doing.' It is most apparent to me that we live in an age where the vast majority of the population is to some extent disconnected from our biological and historical origins. Stone is something that is so primordial. It's the stuff from which soil is made. It's everywhere. The earth. . . ," he chuckles, "is basically a stone. So I think that it may be completely unconscious or subconscious, but stone is an instinctive part of who we are as humans."

CHAPTER 4

The Land Reclaims Its Walls: 1850 to 1920

WITH THE INDUSTRIAL REVOLUTION, MEN ABANDON THE LAND AND WALLS REVERT TO NATURE

The bright, optimistic attitude of the small, independent New England farmer in the post-Revolutionary War period began to darken by the mid-1800s. Many factors, other than the gathering storm of the Civil War, led to this change.

What follows is a brief history of this period, as lived by the settlers of the small town of Warner, New Hampshire. Warner was founded around 1760, after the French and Indian War made the area safer for settlement. Its history chronicles in tragic detail the fate of thousands of similar farming communities throughout the hills of New England.

Warner grew rapidly in the early nineteenth century. It was home to 2,250 inhabitants by 1862. Here

follows an edited version of the town's own official history:

> In the western section of town was a 14,000 acre tract called The Minks. There were 10 different school districts, 12 burial grounds and 140 farm sites. A hard-scrabble area under any conditions, it was the first to lose population. By 1892, Warner's population had dropped over 600 to 1,383. Fifty farm sites in The Minks had been absorbed into neighboring farms or reverted to timber lots. A century later, all the farms in the Minks had essentially disappeared and roads had been discontinued or had deteriorated to barely passable. With the advent of the railroad and its cheap, convenient travel, people had the opportunity to find better paying work elsewhere. Those who wished to stay in agriculture moved west to Ohio, Illinois, and the Great Plains, where nary a rock could be found and topsoil was measured in feet instead of inches.
>
> Those who wanted to stay in New England moved to cities where factories making fabrics and shoes were rapidly developing. Many men from the Minks served in the Civil War. Many died. Their farms were often abandoned. Those who chose to remain faced

This Harvard Forest diorama chronicles the abandonment of the typical central New England farmscape of the mid-1800s. The homestead has been deserted, as the forest silently retakes the edges of the fields and the roads gradually become stream beds.

an increasingly hard life as the thin soil was about worn out. As their children no longer wanted to farm, the parents either rented or auctioned off their farm and moved to nearby villages, or moved with their children to the cities. As children left, schools closed. Roads were no longer maintained. Abandoned houses and farm buildings were burnt down or left to decay on their own. The broad, sweet smelling pastures succumbed quietly to the ever encroaching forest. Without farmers to keep the forest at bay, the woods regained control of the land that had originally been its own. Timber triumphed again, hiding miles of stone walls and handsomely crafted granite foundations. The few remaining families, along with lumber companies, managed the land for the harvest of timber. The small family farm was but a distant memory.

Compounding the problems of the small farm was the advent of mass–produced farm machinery, designed to be drawn by horses rather than plodding oxen. The small, stone wall-enclosed fields prevented the use of these modern implements. "Go West, young man" was the cry—and thousands did.

While farm families searched for greener pastures, the increasingly wealthy middle and upper classes of urban society were searching too. They wanted places to go, particularly in the warm months, to escape the heat and din of the cities. Known as "rusticators," gentlemen farmers, and builders of elaborate stone "cottages," they brought a revival of sorts to the New England countryside of the late 1800s. And with their estates came a whole new style of stone wall.

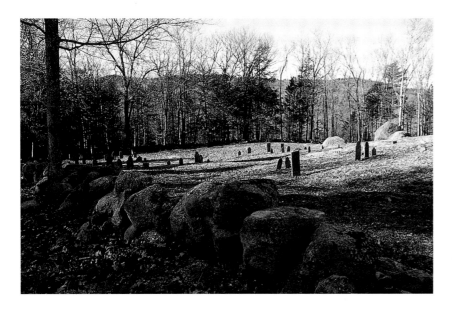

The Old Parade Ground Cemetery in Warner, New Hampshire, stands in mute testimony to the brave, idealistic souls who first cleared this land and buried their first family member here in 1784. Still lovingly cared for, this cemetery is draped on the shoulder of a hill some one hundred feet above the town. The view surely would have been different two hundred years ago, as most of the distant hills would have been cleared for sheep pasture.

It doesn't take long for trees to reclaim the land they traditionally owned. White pines, seeded by parent trees from the now totally wooded field on the left, are slowly and inexorably invading this recently abandoned pasture.

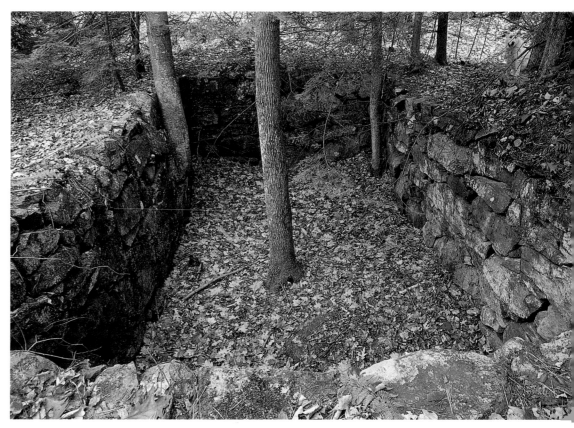

In the hills above Warner, a well-laid foundation is the only remaining sign of a family's dreams of self-sufficiency and future happiness.

A north-south running wall in the Minks area of Warner probably divided pasture land and served as a property line. A scientist once theorized that the stone walls built in central New England between 1810 and 1840 held a mass "greater than that of the great pyramids of Egypt."

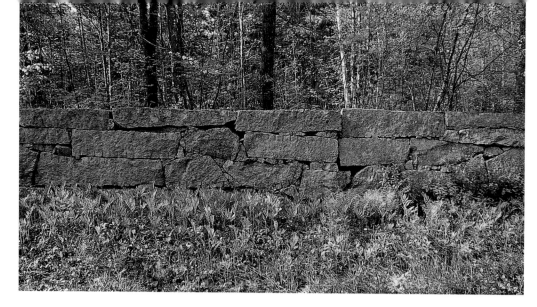

This estate wall of the 1870s runs for nearly half a mile along a road in Sandwich, New Hampshire. Built almost entirely of quarried stone, it dramatically states, "I have arrived." The wall is six feet high and five feet wide, truly a monumental structure for a small country village.

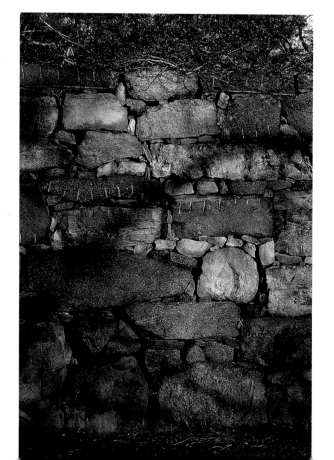

This estate wall in Greenwich, Connecticut, rises some seven feet, effectively shielding the property from the passing world. The stones in the lower section show no drill marks, so it is probable that the upper part was added at a considerably later date, when grander walls were more in fashion.

A **mosaic wall** *gives a much more formal appearance through selective use of size, shape, and color. A wet wall, built in 1897, fittingly located on the property of the Masonic Lodge in North Adams, Massachusetts, demonstrates some refined wall-building techniques.*

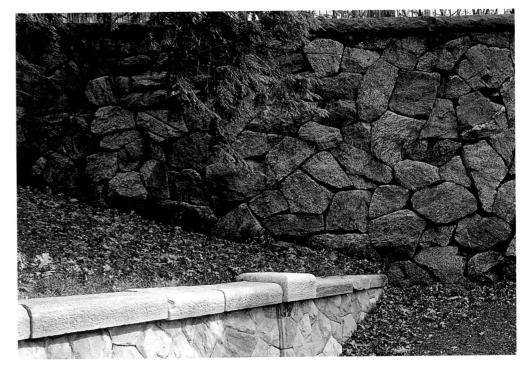

A **chinked wall** *like this one in central Connecticut, is just what it says it is—generally a well-laid smooth-faced wall that the waller has made even smoother by filling the gaps with smaller chinks. Wedge-shaped stones are best locked into place by pushing them into gaps from the inside.*

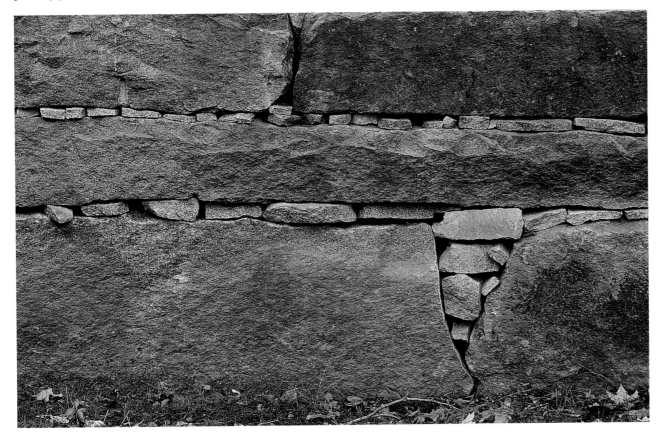

The **estate wall**, *or* **wall of affluence** *of the turn-of-the-century period is a carefully laid-up structure, most often constructed of quarried stone. While farm walls typically progress from single wall to double to laid up to capstone over a period of years, the estate wall was built from start to finish in a single time period, most often by a gang of masons.*

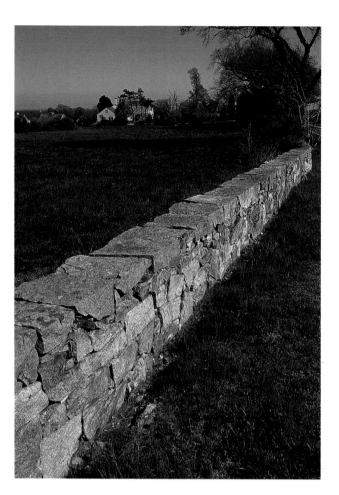

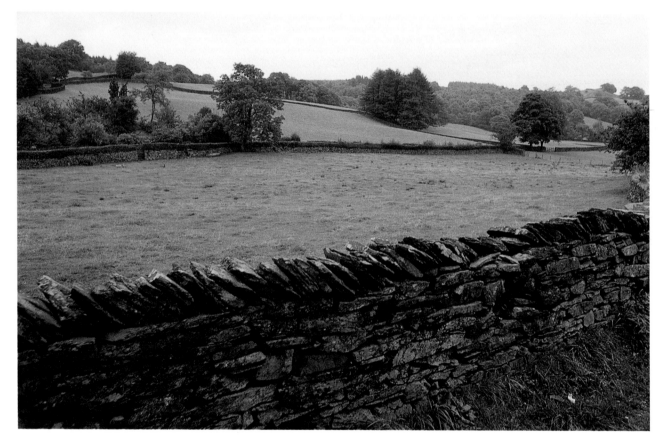

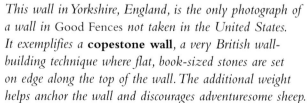

This wall in Yorkshire, England, is the only photograph of a wall in Good Fences *not taken in the United States. It exemplifies a* **copestone wall**, *a very British wall-building technique where flat, book-sized stones are set on edge along the top of the wall. The additional weight helps anchor the wall and discourages adventuresome sheep.*

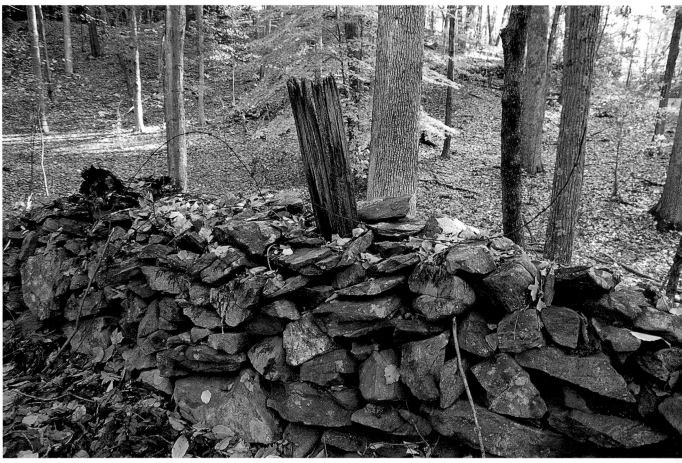

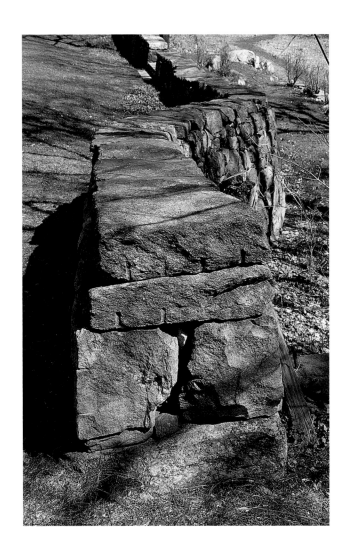

This relic in Bridgewater, Connecticut, represents a sea change in New England wall building—barbed wire on a chestnut post. In 1874, barbed wire was patented by Joseph Glidden, a New Hampshire native transplanted to the West. Suddenly an inexpensive form of fencing was available. Almost overnight the value of stone walls plummeted. Thousands of miles of wall soon disappeared— for many by undignified burial or by being thrown into the stone crusher.

In wall building, the term **batter** refers to a technique whereby the wall diminishes in width as it increases in height. By slanting the sides toward the center some fifteen degrees, the pull of gravity, which is what holds a dry wall together, is focused more to the center of the structure.

This wall in Warner, New Hampshire, has probably not seen a cow in more than a century, but the narrow slit in this wall is called a **cow slip**. *It is also known as an* **open stile, grike**, *or* **cow stile**. *Perversely named, the cow slip is designed so humans—and even yellow Labs— can slip through, but cows cannot.*

Step stiles, *for climbing over a wall, take various forms. The tread portion can be cantilevered out, which requires a sizable mass of wall to anchor them properly, as in this example in Litchfield, Connecticut.*

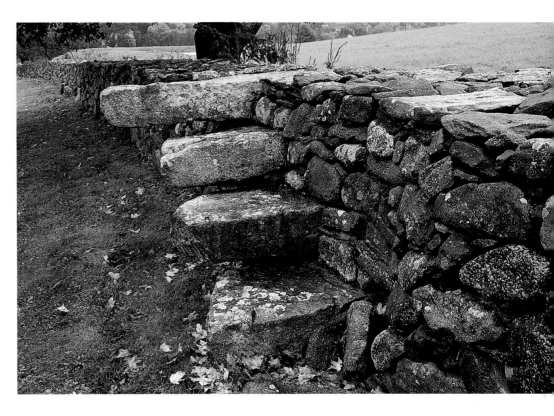

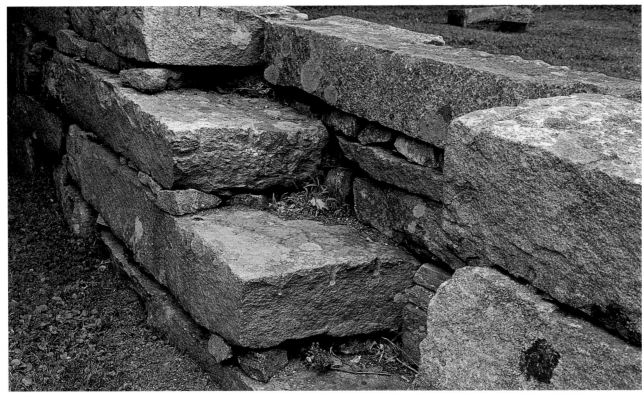

Stiles may also be built into an especially wide wall, like this cemetery wall in Goshen, Connecticut.

The last half of the nineteenth century saw the stone construction of public works reach its zenith. This beautiful dry wall double bridge, with arches of near perfect semicircles, spans Beards Brook in Hillsboro, New Hampshire. Kevin Gardner, who showed me this bridge, said, "Isn't this a fabulous bridge! Keep in mind that bridges are walls. They're just retaining walls laid back-to-back. The only specialized structures that are not wall-like within them are the vaults themselves."

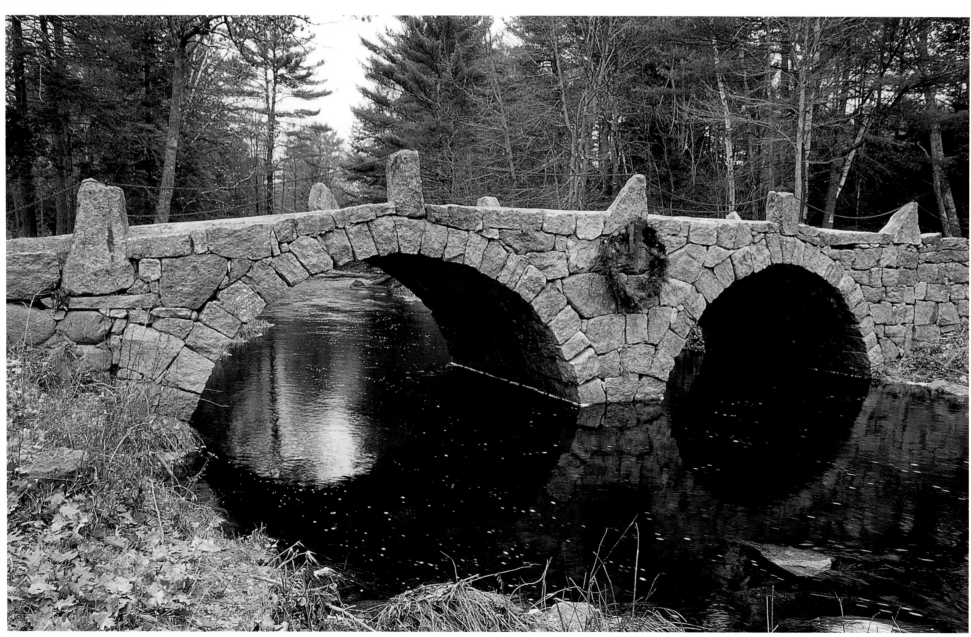

The Gleasons Falls Bridge, also in Hillsboro and also of dry wall construction, is unique because, as Kevin explains, "Its 'span to raise ratio' is four to one, which means the arch is four times as long as it is high. The lower you go with the arch, the more of a feat it is to get the arch to stand. This flat span is one of the reasons this bridge got on an American Society of Civil Engineers list of excellence, which includes such structures as the Hoover Dam."

Dams are a very specialized type of wall. They were the major source of power for the embryonic industries of New England. Some of the best built ones are still intact after two hundred years. This one stands near Abington, Connecticut.

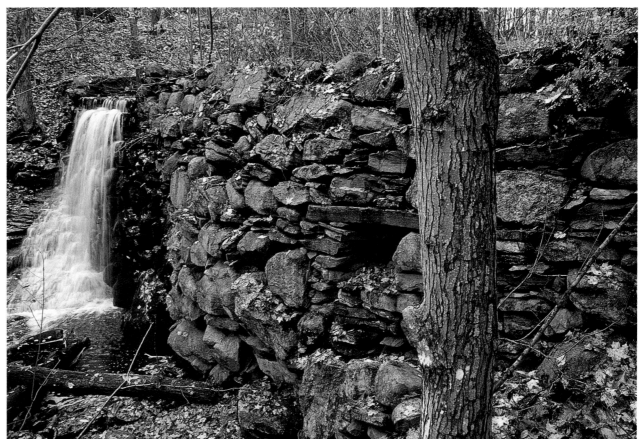

Welcome to the main street of Dudleytown, Connecticut. Perched so high above the Housatonic River on a steep, rocky hillside in the northwestern part of the state, one wonders why anyone would choose this spot for wresting a living from the miserable soil. Nonetheless, the land was settled in the mid-1700s and grew to be a hamlet of several dozen families. But by 1899, they were all gone. A series of suicides, unusual deaths, a murder, and cases of insanity lent credence to the rumor that the town's founders brought a curse with them from England.

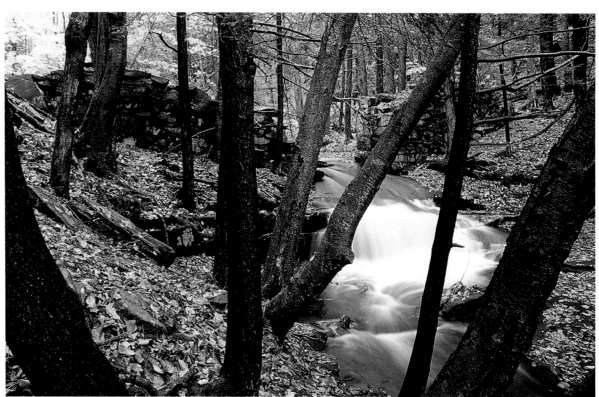

Today, all that's left in Dudleytown are the stone ruins of the settlement. The sluice-way of the dam washed out long ago. Garden plots now no longer raise vegetables but produce instead giant oak, maple, beech, and hemlock trees.

Even the lines of Dudleytown's drystone foundations have almost disappeared under forest debris. One can barely discern the location of the chimney base where fires once kept a family warm and secure during frigid winter months on this north-facing hillside.

A retaining wall that once echoed cries of the draymen as they urged their plodding teams of oxen up the steep hillside now molders in the silence of the woods. Only the scuffle through the leaves of an occasional hiker or the rustle of a passing porcupine breaks the stillness. But then, too, there are reports of signs of the supernatural, possibly attributable to the curse for which Dudleytown is notorious: inexplicable lights and noises in the dark, a mysterious feeling of being touched by some invisible force, and often feelings of malaise, gloom, and depression. Might there be more than old walls in Dudleytown?

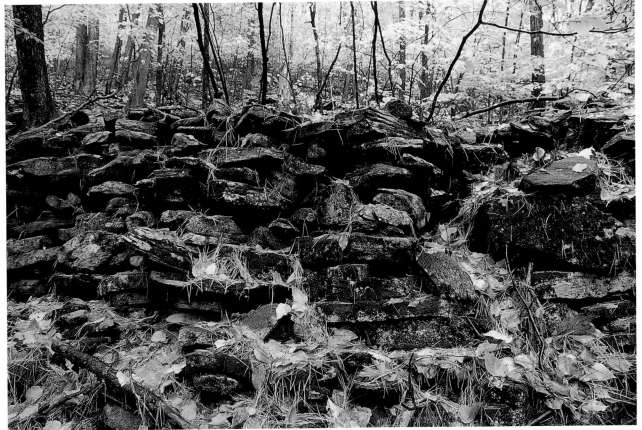

In 1869, a New York City financier bought a large property in the center of Brooklyn, Connecticut. He had his roadside property boundaries marked with these wonderfully whimsical walls that heralded the onset of gentrification in the area.

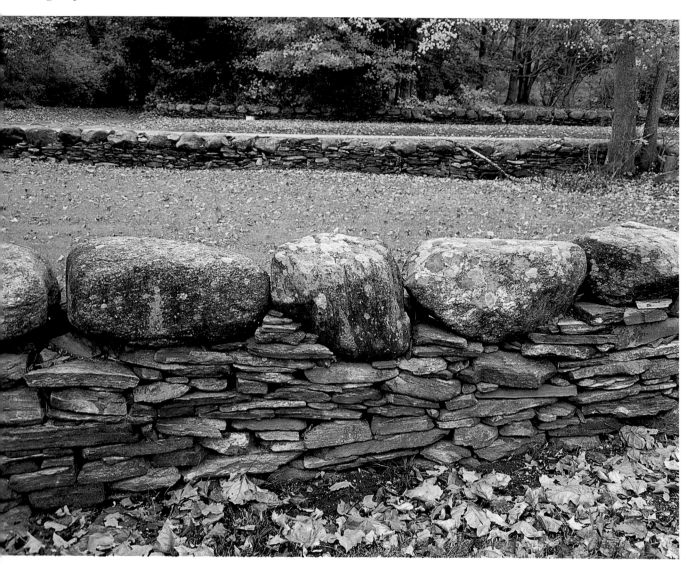

Embedded in a roadside wall in front of a Rumney, New Hampshire, cemetery is a hitching ring for securing a horse—a common nicety in the age before automobiles.

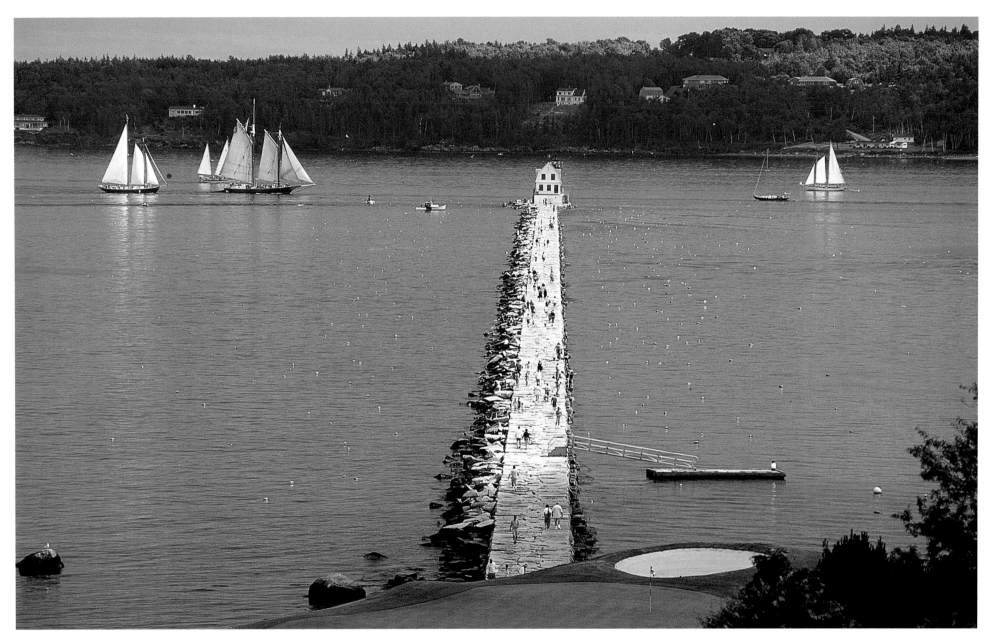

Begun in 1881, the mile-long breakwater in Rockland, Maine, took eighteen years to complete, using seven hundred thousand tons of granite.

Often the thickest, strongest walls on a farm were those around the area where the animals were kept. These walls, with their sturdy capstones, can be seen at Sturbridge Village in Massachusetts.

This wall in Kennebunk, Maine, would be considered a lazy man's wall were it not for the fact that the stones measure six to ten feet long and weigh tons. But then, builders only had to move ten stones to make a wall ninety feet in length!

The title for this book, Good Fences, comes from Robert Frost's famous poem, "Mending Wall." Frost pokes fun at human nature through his musings about stone walls, their upkeep, and their symbolism. As he and his neighbor walk along their mutual boundary replacing the frost-heaved "boulders," his neighbor murmurs the rote phrase he learned from his father, "Good fences make good neigbors." This small wall is part of one that encloses a field behind Robert Frost's home in Derry, New Hampshire, where he lived when he wrote "Mending Wall."

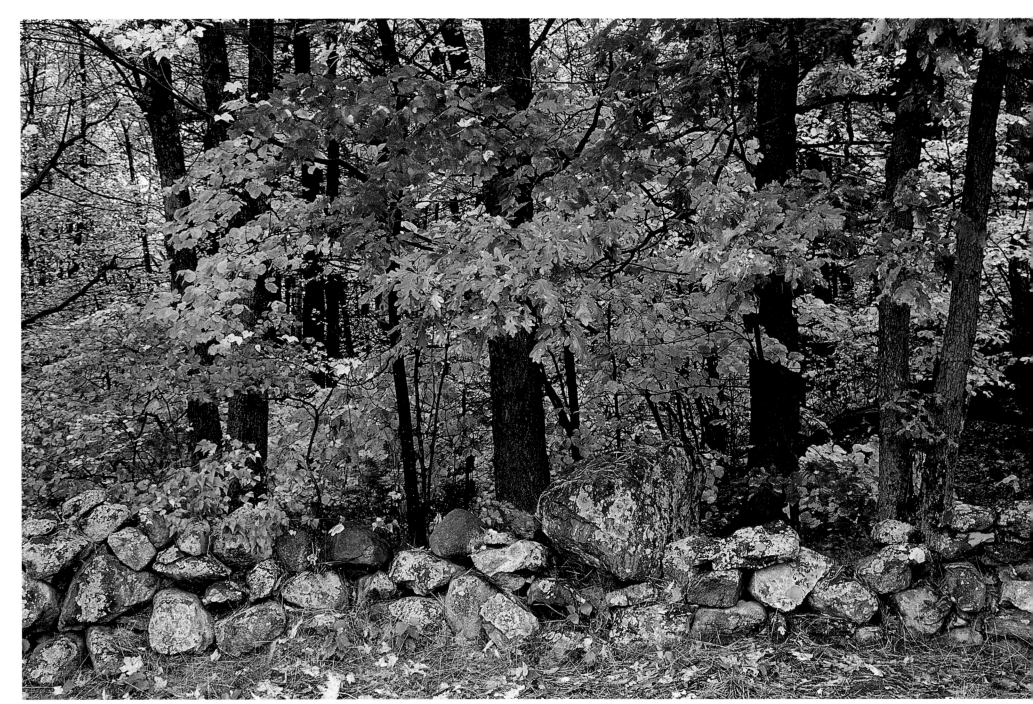

WALL BUILDER: KEVIN GARDNER

Kevin Gardner of Hopkinton, New Hampshire, is a Renaissance man—actor, teacher, New Hampshire Public Radio writer/producer, author of a marvelous book on building with stone, *The Granite Kiss*, and, most importantly, from my point of view, a wall builder for thirty-five years.

I met Kevin at a wall-building class he taught at the New Hampshire Farm Museum in Milton. The project involved students dismantling a section of 150-year-old double wall that formed one side of a cattle run, observing how it had been built, and then rebuilding it properly.

"Building a wall is mainly the act of memorizing a hole, then trying to find a stone to fill it," he told the class. "You need to avoid working backwards. If you go to pick up a stone and then go looking for a place on the wall where it's going to go, you are working backwards. This has several bad consequences. For one thing, you use up all of your best stones too soon. You're left with a pile of junk so your productivity and your patience begin to deteriorate very quickly. But the most important reason is that when you work backwards, you are wasting your own energy. Whereas, if you pick the *spot*, and then go looking for the stone that suits *its* needs, you will pick up far fewer stones and every stone you pick up, or at least most of them, will go to a place in the wall right away."

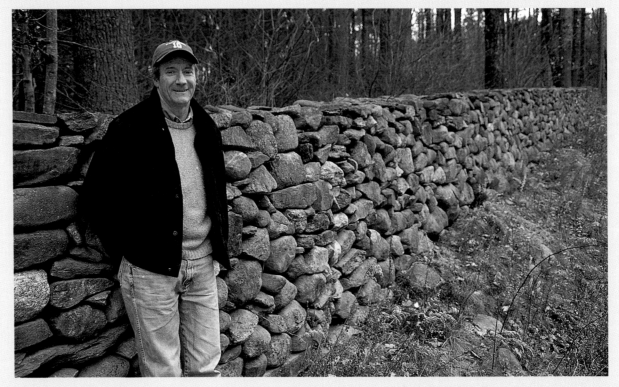

Kevin Gardner stands by one of the walls he has built. He laid it up over two summers. It is about 400 feet long and contains some 150 to 200 tons of stone.

I asked Kevin why he felt there is such interest in stone walls. He replied, "I will say that some people are fascinated by stone walls because they can't comprehend what it took to make them. Some people are fascinated by stone walls because they are in love with the look of a particular regional landscape and walls are part of that. Some are fascinated by stone walls because they actually can feel something deeper about the way that the landscape is disposed of and how it once operated. They have either nostalgia or attraction for that operation. By no means is interest in stone walls due to one single thing."

Kevin came back to the subject of the wall builders themselves, "I have nothing but admiration for the eighteenth- and nineteenth-century builders—those men, women, children, Native Americans who went before us. I'm quick to say that some of them were lousy wall builders. But some of the integrity, of the sheer determination, that you can see in so many of these walls is

just astounding. We have to be very careful about getting too nostalgic about this determination." He chuckles at our 20/20 hindsight. "It also expresses a kind of desperate, and ultimately defeated struggle to create lasting farmland out of this *mess* of northern New England landscape. We're looking at the wreckage of a massive failure that had a little, bright shining period of time, from maybe just before or just after the Revolution to about 1840, and then went into a long spiral of ruination."

In his work, Kevin Gardner spends a great deal of time rebuilding old walls. He is heartened that these old stone relics interest the general public. He told me, "The people who are really excited about stone walls are the people who didn't grow up here. Those are the people that we are gaining by the thousands. People who are genuinely interested in learning about what happened here are growing in proportion to the total population—but the real reason we're getting more interest is that we are losing the things [walls] themselves. I am really looking for a way to somehow preserve some feeling, or honor, for this old landscape that we see disappearing so rapidly. That's a hard thing to do. And a lot of people are trying to do it. Good luck to us."

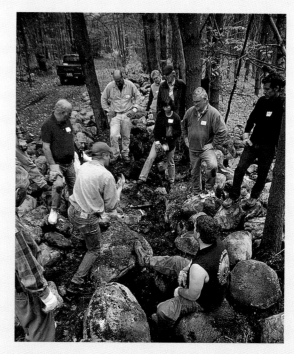

Kevin (in the green cap) points out to the class lessons learned in the disassembling of an old wall.

A well-laid wall of cut stone sets off the perimeter of a Connecticut farmhouse.

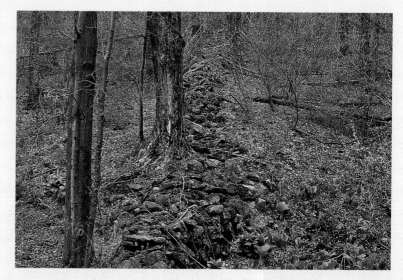

Farmland, long abandoned, has grown into woods in central Connecticut.

Stone Walls Today

"SOMETHING THERE IS THAT DOESN'T LOVE A WALL"

In putting this book together, I have focused on the building of the walls, but understanding why walls fall down deserves attention as well. In his 1911 poem, "Mending Wall," Robert Frost lists some of the many reasons walls tumble down—gravity, hunters, and the freeze-thaw cycle, to name a few. But many other less obvious factors contribute to a wall's ultimate demise.

The enemies of stone walls may be classified into two main groups: man and the forces of nature. While man has a fearsome arsenal for destroying walls, nature, in time, is sure to do the job more efficiently and completely. From the subtle dissolving of minerals in stone by acid rain to the dramatic uprooting of a giant oak tree growing beside a wall by a hurricane, nature has ways of eventually reducing man's heroic building efforts to small piles of sand and clay. But all is not going downhill. In recent years there has been a marked increase in interest in stone walls in general and in building or repairing them in particular.

Wall builder Kevin Gardner says, "During the time we've been in business [building walls], generalized interest in what we do has become far more active." Kevin believes that these walls, relics of times long gone, are being increasingly appreciated as essential elements of New England's landscape at a time when open land, and the walls themselves, are rapidly disappearing.

Author J.B. Jackson's book *The Necessity for Ruins* articulates another reason for the stone wall renaissance. He says that first there had to be "... a golden age" that in time becomes abandoned. Only after the passage of time and neglect do elements of that golden age reappear in a new light and popularity. Jackson emphasizes that "... there has to be that interval of neglect, there has to be discontinuity ... the old order has to die before there can be a born-again landscape."

The old order has certainly passed away. Many property owners in New England are now seeking this "born-again landscape." But to understand the behavior of stone walls, it helps to know, in Frost's words, what the force is "... that doesn't love a wall." By knowing the enemy, it is easier to bring back and even maintain a golden age.

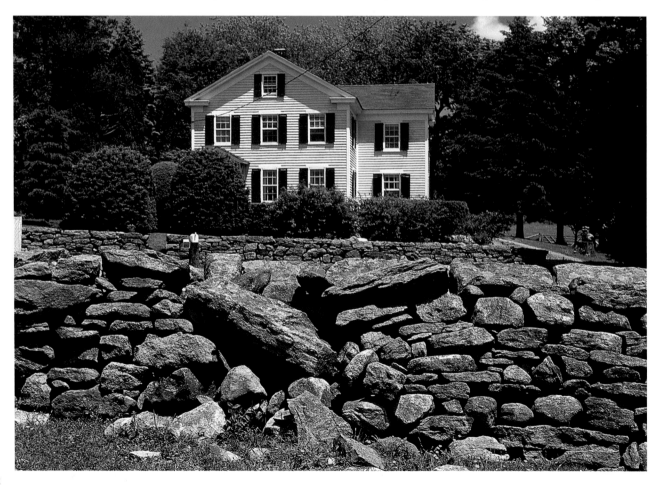

*This wall most probably failed due to a **blowout**, the result of stone shifting in the lower portion of the wall. The exact process is explained on page 87.*

Theft of walls has become more commonplace as the price for aged fieldstone continues to rise. On back roads in New England, one often comes across walls—such as this one in Salem, Connecticut—that have suffered major extractions.

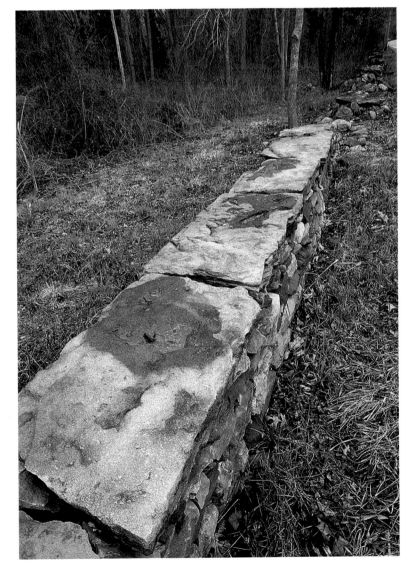

A well built wall, with beautiful capstones, in Tiverton, Rhode Island, comes to a halt at a section where only unwanted rocky debris has been left by a thief in the night.

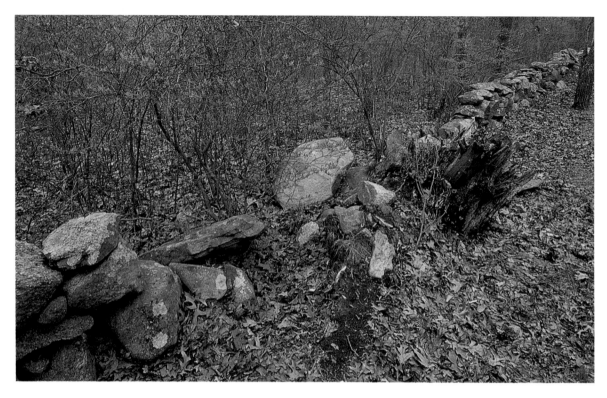

Roadside walls also suffer from errant drivers. The cars are
fortunate; they can be taken to be fixed. But the walls
are seldom repaired.

A farmer in Vergennes, Vermont, showed me this wall,
admitting that he, as a very young hunter, had ripped the
wall apart. Why? To quote Robert Frost's "Mending Wall:"

"The work of hunters is another thing:
I have come after them and made repair
Where they have left not one stone on a stone,
But they would have the rabbit out of hiding,
To please the yelping dogs."

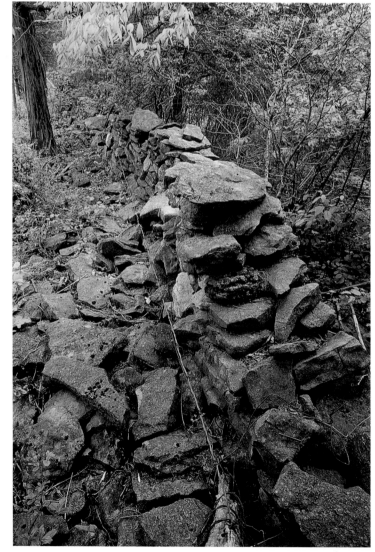

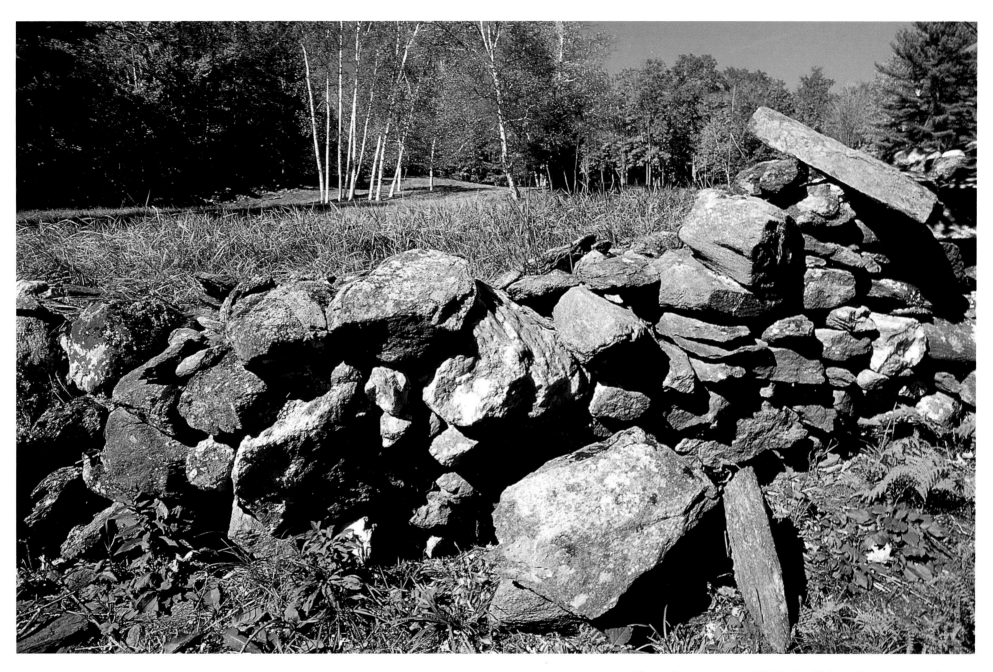

If a wall runs across a hillside, it will be subject to **creep**, the term used to describe the pull by gravity on the slope's soil. Originally, this wall was freestanding. Over the years, creep and erosion—if this field had ever been cultivated—has brought soil to the top of the wall's uphill side, turning it into a retaining wall. The wall is succumbing to the pressure, the top stones are sliding off, and in time, the wall will crumple. Gravity wins again.

Ever since the invention of the stone crusher in 1852, and the automobile four decades later, roadside walls have suffered greatly. As roads were widened from carriageways to motorways, the mechanical rock-chewer swallowed up thousands of miles of New England stone walls which were then buried ignominiously in roadbeds. Occasionally, such walls were halfheartedly rebuilt, but generally they were bulldozed aside or the stones sold to a mason for use elsewhere.

Of the many reasons stone walls fail, some of the most subtle are acid rain and similar processes. These stones in a Stonington, Connecticut, wall were undoubtedly in one piece when the wall was laid up. They have been reduced to their current condition by a combination of chemical and climactic changes. Whether the moisture falls from the sky, or is created when water melds with decaying vegetation, the result is the same: a minute amount of certain chemicals is dissolved from the stone. Over time, small fragments of stone will break loose. These fragments might be underneath a key element in the wall's structure. Its loss could be all that is needed to bring down an entire section of the wall.

When double walls collapse, it is often because of a **blowout**. *This occurs in the interior center portion of the wall, if it is not packed carefully and tightly. Even though the interior portion is not visible, its structure is crucial to the wall's integrity. If stones are just dumped in between the two outside courses, they will settle over the years. As they settle downward, the tops of the outside walls will tilt inward, placing a great deal of outward pressure on the bottom exterior stones. In time, a stone in a lower course will pop free, creating a blowout.*

This is a beautiful Civil War-era barnyard wall located in Lyme, Connecticut. The run of the wall, going from the foreground to the road, appears as solid as the day it was built. But the section coming in from the right shows problems. The capstones are tipping into the wall's center.

Seen from another angle, however, one can see why. For some reason, less care was given to tightly packing the wall's interior in this section. The center has settled noticeably and a blowout is inevitable. In fact, the picture introducing this chapter is a portion of this same wall where a blowout has already occurred.

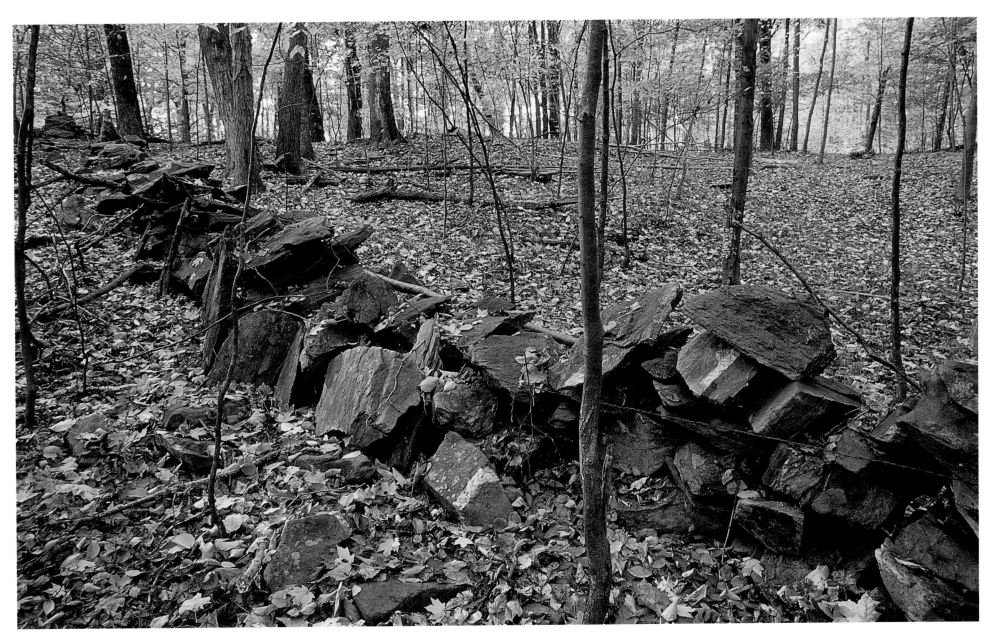

Walls built on the periphery of a farm tend to be much less well made than those that were frequently seen. The stone for this wall is angular—well-suited for the purpose. Inattention to proper building methods, however, often produces these "haste makes waste" results.

89

I was able to determine, without a doubt, the cause of this wall's collapse . . . for it happened to me on our farm. After clearing the collapsed stone back to solid wall, I discovered a partially buried, rounded boulder in the center of the hole. As the foundation had been poorly prepared when originally built a century ago, this rounded stone acted as a ball bearing for the rest of the wall as it flexed around it during the freeze-thaw cycle, weakening the whole structure.

The butt end of a wall requires special attention. Single walls such as this are simpler to build, but if the end isn't securely tied in to the rest of the wall, it can't perform its "bookend" duty properly, and the wall will fail.

Far from any current habitation, this six-foot-high section of wall on Bethlehem, Connecticut, land conservancy property, has stood well the test of time. Why it was built so tall no one seems to know.

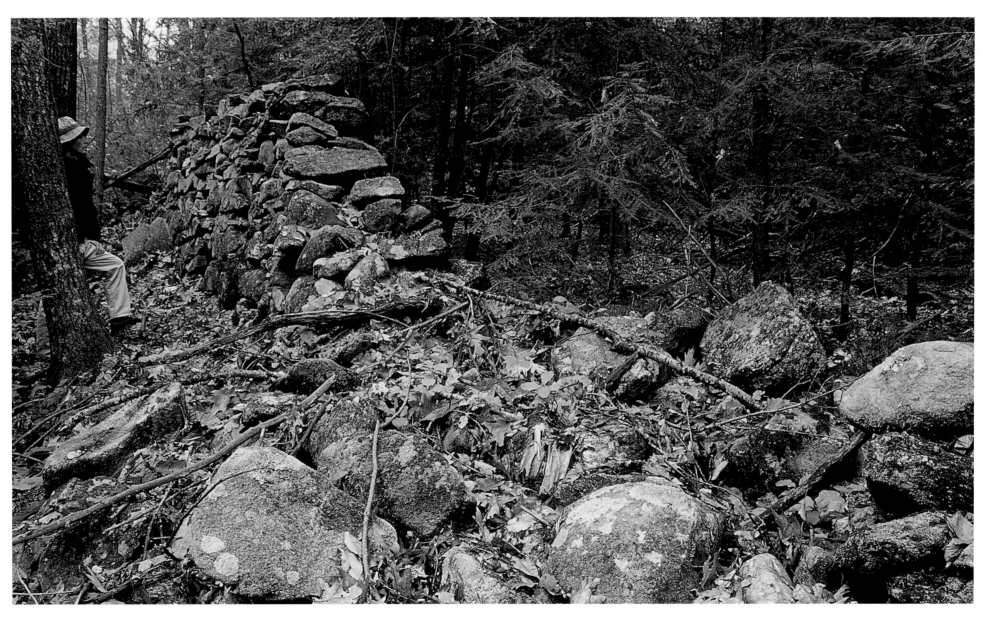

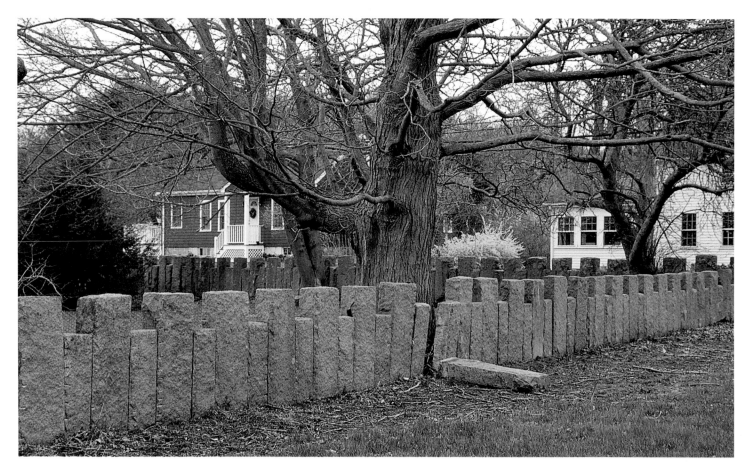

Trees and stone walls do not mix. Yet because the damage often happens slowly, it is rarely noticeable until it's too late. Quietly adding an eighth of an inch in girth a year, a tree planted too close to a wall can grow enough to eventually knock part of it over, as happened to this wall in Westport, Massachusetts.

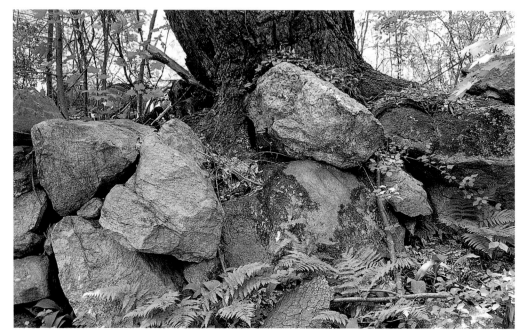

Like an insatiable python, this large pine has almost completely swallowed a portion of wall behind the McLaughlin Gardens in South Paris, Maine.

As the organic material in this tree trunk decays, it will filter down into the wall, creating a seed bed for future trees. They will grow and further spread the wall's stones. In a few centuries, if left unattended, little of this wall will remain.

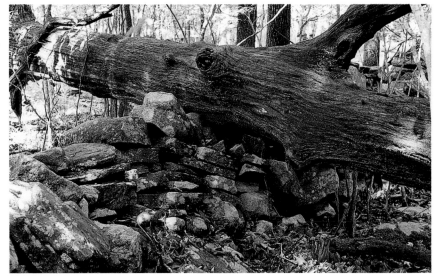

Occasionally, a tree's root system will find its way straight down through a wall to the soil beneath, pushing stones aside as it grows. And when the tree ultimately falls, a large chunk of wall will fall with it.

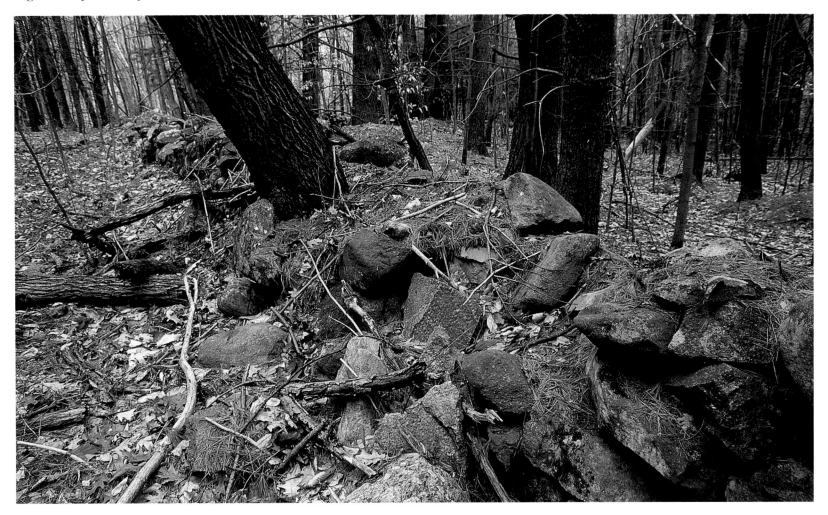

No matter which end of the tree hits the wall, if the damage is not repaired, the breakdown of the structure of the wall will slowly accelerate. A stone in a well-made wall depends on those on either side of it for additional strength and security. Once the wall is breached, this security is compromised. This weakness spreads slowly like an infection in both directions.

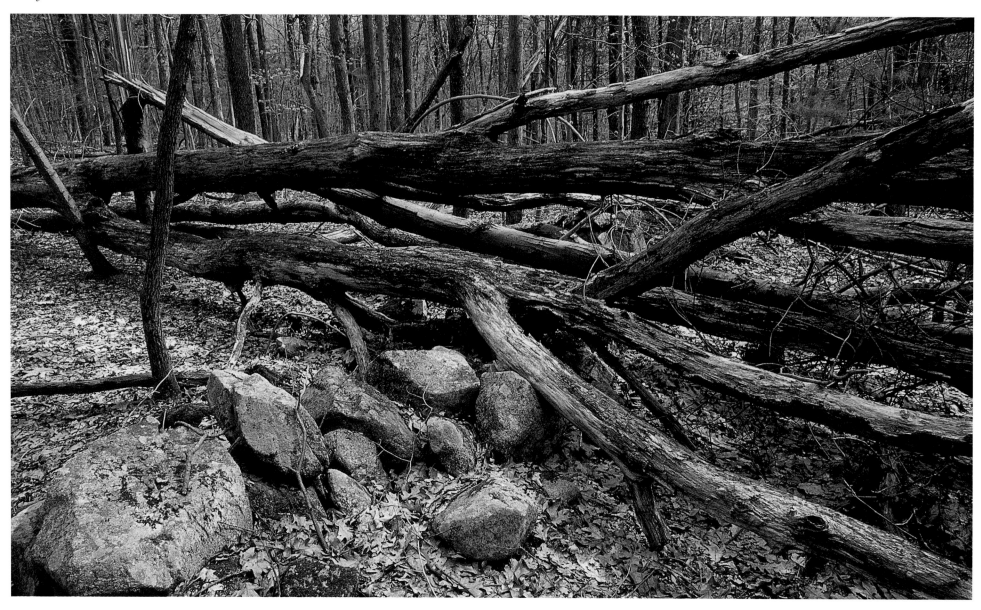

Modern equipment makes short work of field clearing drudgery. Wanting to expand our Connecticut garden, this is what we came upon just beneath the surface. We buried the mess at the foot of the garden. Unwanted garden rocks aren't all that's been buried in New England, though. This procedure has also "disappeared" thousands of stone walls.

Here's what former Maine bulldozing contractor and author W. H. Bunting says about burying stone: "Only someone with a rock for a head could bury stone walls without feeling just a little ashamed of himself, effortlessly erasing monuments of the prodigious labors of man and beast with a machine magically powered by petroleum. Only pushing in stone-lined, hand-dug wells seems more disrespectful. For the record, the technique I use for burying walls—walls are buried to expand small, old fields into larger fields suitable for modern farming equipment—is using a large dozer. I drive right in and dig a hole, or trench, parallel to the doomed wall, perhaps five feet deep and thirty to forty feet long. Then the portion of wall alongside the hole is pushed in and leveled. Of course, nowadays, anyone wishing to get rid of a wall would first call a stone buyer. The news that rich people pay large amounts of money to have stones brought on their land, rather than off their land, would likely persuade even a few dead and buried rock-ribbed Yankee Republican farmers that the upper bracketed income taxes were far too lenient."

The walls on this page all share a common factor. They run in an east-west direction, presenting their southern sides to the warming rays of the sun during the spring freeze-thaw cycle, while the northern sides stay shaded, snow-covered, and frozen solid for a longer time. While there are many reasons why walls fail, one of the less obvious might be that the constant contracting and expanding of the underlying soil on the south side compacts the earth while the northern side remains frozen. Over the years, without proper foundations, the southern side might compress more, leading to the instability seen here.

In the upper right is a wall adjacent to one of the oldest houses in Old Lyme, Connecticut, founded in 1665. On the lower right is a farm wall in Stonington, Connecticut, and in the lower left is a retaining wall with an impending structural "blowout," located in Rumney, New Hampshire.

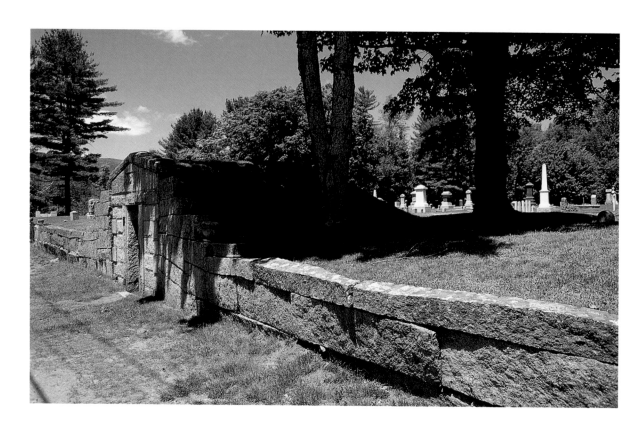

Picturesque in its quiet winter beauty, this wall in Glasgo, Connecticut, seems passive and serene. Yet it actually is influencing many aspects of its surroundings. It causes snow to pile up in one area and blow away in another. Its dark stones soak up the sun's heat and transfer the warmth to the soil. Come the spring thaw, it will influence the way rainwater flows down the hillside. It will provide habitat for countless small creatures which would otherwise have nowhere to hide. If maintained, the wall can last for generations. If not, the stones will eventually tumble down and become just rocks again. Nature will triumph in the end.

WALL BUILDER: CRAIG ARONSON

Craig Aronson is a wall builder based in Litchfield, Maine, fifty miles north of Portland. When I met him, he was begining a patio project that required building a retaining wall, a freestanding wall, a barbeque, and a patio floor, all of drystone construction.

I commented that he must have used stone from many sources for the patio. "Yes," he said. "I've gotten this stone from a house foundation, from my own old walls at home, from my own collection at home, which I've built up for more than fifteen years, from three different quarries, and who knows where else—probably ten to twelve sources for this one job." He continued, "When the old timers didn't have exactly the right materials at hand, they'd pick some big, old, gnarly boulders and they'd lop them into chunks that had faces on them. Most of the cut stuff in this project came from the foundation piers of a late eighteenth-century house that burned sixty-five years ago."

Craig's whimsy shows through in his creation of a shark-style retaining wall.

A stone mason for twenty years, Craig Aronson stands by a just-completed drystone patio project in Brunswick, Maine.

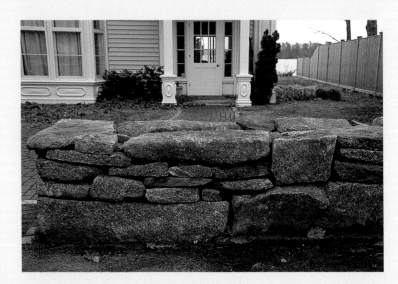

Aronson chose well in selecting the granite for this wall on the Maine coast in Freeport.

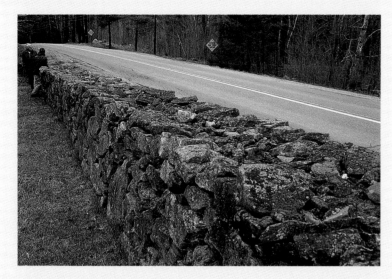

Craig took me to see an older wall he'd always admired and to meet its current owner who told me its history.

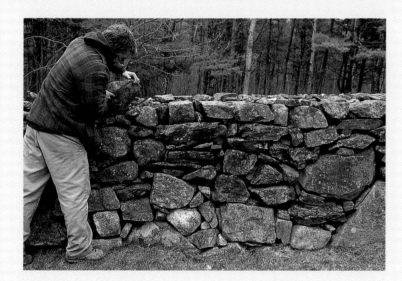

In passing, Craig adjusts a capstone on this wonderfully robust seventy-plus-year-old drystone wall.

The wall, three feet high by four feet wide, is nearly a quarter of a mile long on the west side of the road and 225 yards long on the east. Estimating the stone at 160 pounds per cubic foot, we guess the west side wall contains over 1,224 tons of stone.

Over the years, I had often passed this wonderful drystone wall and wondered about its history. Craig introduced me to its owner who told me he ". . . called the woman who lived here then . . . she was ninety-six and sharp as a tack. She told me that her brother had it built in honor of their mother. It was started in 1932 and finished in 1937." He went on to tell us that her brother, a doctor from Rhode Island, came here during the summers. The owner continued, "She told me that her brother allowed anybody to work who showed up that day. Paid him a dollar a day. And if they brought a load of rocks, paid them two dollars a day. This was at the height of the Depression—a pretty tough time, I understand. Her brother felt he was doing two things, she told me—helping the local people financially while giving them something to do." Knowing how well the wall was made, Craig added, "There had to be a couple of masterminds. Everybody who showed up with a wagon full of rocks wasn't allowed to put rocks on the wall. But they could fill the middle and do all the rough work." Talking about the design of the wall, Craig said, "Well, it's the old style. They just put 'em in as they seem to fit the hole they'd made from the last two that they put in. You know, they just keep stacking as they fit, an' that would leave a hole, an' they'd place another one into the hole that fit an' they'd just keep go'n and go'n, so it has a very random look. Everything isn't trying to be linear. The wall is stacked up—two faces—and then anything that wasn't good enough to go in the faces, or too small, was just heaped in the middle. The idea is also to get some **through-stones** in from side to side, but I don't know if they have any in here. Because it is so wide, I think that just the tapering of it will let gravity take over. This is a randomly built wall that they pulled off quite nicely. It's held its dimensions. It's pleasing to the eye."

Then with a twinkle and barely suppressed hubris, Craig adds, "I've got walls I've built that look just like it. I'd like to think that they'll still be around after the amount of time that this one's been standing."

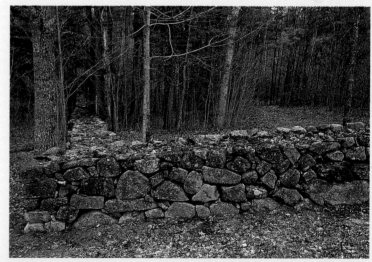

CHAPTER 6

Construction Techniques, Unusual Walls, and Miscellany

"HUMANS FEEL BETTER AFTER A GLIMPSE OF THE EARTH'S CRUST"

Stone by Stone author Robert Thorson told me, "Humans feel better after a glimpse of the earth's crust. Without canyons, road-cuts, or coastal headlands, where else would we go to see it except for stone walls?" Many people echo this seldom articulated but subliminally felt need when asked about stone walls. "I love looking at these walls," said one Maine tree farmer, "there's something so peaceful about them." The director of a Connecticut land trust made

a similar point. "My own land is surrounded on three sides by stone walls. I feel reverence each day I see them. They constantly remind me of my heritage and my duty."

I confess that I feel a similar, but much stronger feeling of awe and connectedness by lying on my back looking up at the stars on a summer night than I do looking at a stone wall, but the instinct seems to me to be the same. Be it sunset over the water or moonrise

over a mountain, we all recognize, consciously or unconsciously, how deeply we're connected to our environment. Fortunately, the stones collected into walls can satisfy this instinctive need.

This connection is made all the stronger when we learn the answers to some questions about how these walls were built. What can the old cemetery perimeters say about the art of wall building? What are the advantages and disadvantages of building dry wall versus wet wall? What were the tools and techniques used a hundred, two hundred years ago to move one-ton monoliths, thereby turning rocks into stones?

Turn rocks into stones? Aren't they one and the same? After having given it some thought, there does seem to be a difference. I've never heard a wall builder in New England refer to his product as a "rock wall." In fact, one told me, "When I hear someone say 'rock wall,' my first reaction is that they don't know anything about wall building." What causes the difference? Try my solution on for size: Just as we don't have a "stone-ribbed coast of Maine" or "the Stone of Gibraltar" or "bedstone," we also don't have a "Rosetta Rock" or a "Blarney Rock" or "tomb rock." The difference seems simple and straightforward to me. A rock is that hard material that will always be a rock—

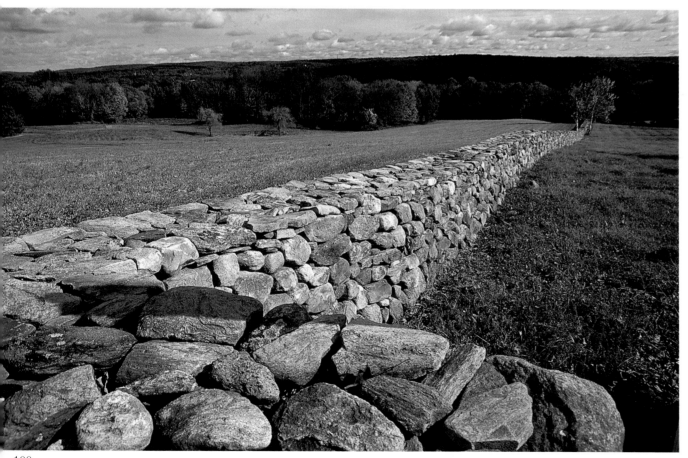

This beautiful sweeping hillside meadow in Roxbury, Connecticut is enhanced by a newly built wall.

until it is put to use by human beings. We change rock into a stone by removing it from its natural environment so that it can fulfill a human need.

Whether it be a new wall defining a freshly cleared pasture or an ancient relic in the deep woods, the stone walls of New England succeed in sustaining us in ways that are both practical and spiritual. They are, in all respects, "*good* fences."

Most of the walls were laid with stones pulled fresh from the fields as they were cleared. But what about the rocks that were too big to move? How were the walls of cut stone created? Most were formed with tools as simple as these (sledgehammers, crowbars, chisels, drills, and wedges), with the addition of lots of muscle power.

A quarrying site in Princeton, Massachusetts, where at least six rocks show drill marks left by the pin and feather splitting process.

These are the simple rock splitting tools used before the advent of the power drill. Two sets of pins and feathers (also known as plugs and wedges) are seen in profile, while three sets are shown in the drilled holes, waiting for the hammer blows that will split the granite when delivered in sequence. The split stone face will show the characteristic half-round marks of cut stone, some three to five inches long and one-half to one inch in diameter, and spaced three to eight inches apart on average.

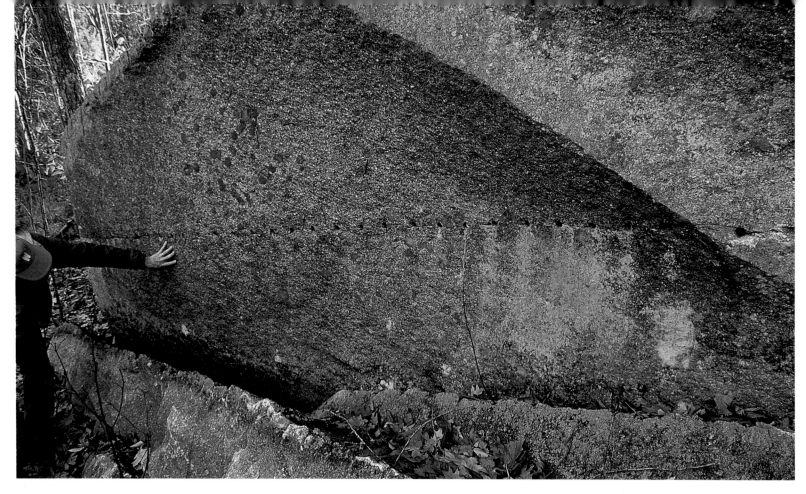

A quarrying site in the Minks area of Warner, New Hampshire presents an interesting problem. At some point—probably 150 or more years ago, when this area was more populated—someone laboriously drilled 36 holes along a 15-foot crack in an 8-foot-high ledge of granite. How were they going to lift that huge top block of stone? The answer might be that they planned to cut it up into smaller slices. Instead, fed up with New England's rocks, they might well have headed out to greener, less rocky fields in the developing West.

On Martha's Vineyard, Massachusetts, a lone glacial erratic presents another failed rock-splitting effort. The great-great-nephew of the man who actually drove the pin between the two feathers gave directions for finding this relic in a back pasture. The iron pieces have been frozen in this boulder for more than one hundred years.

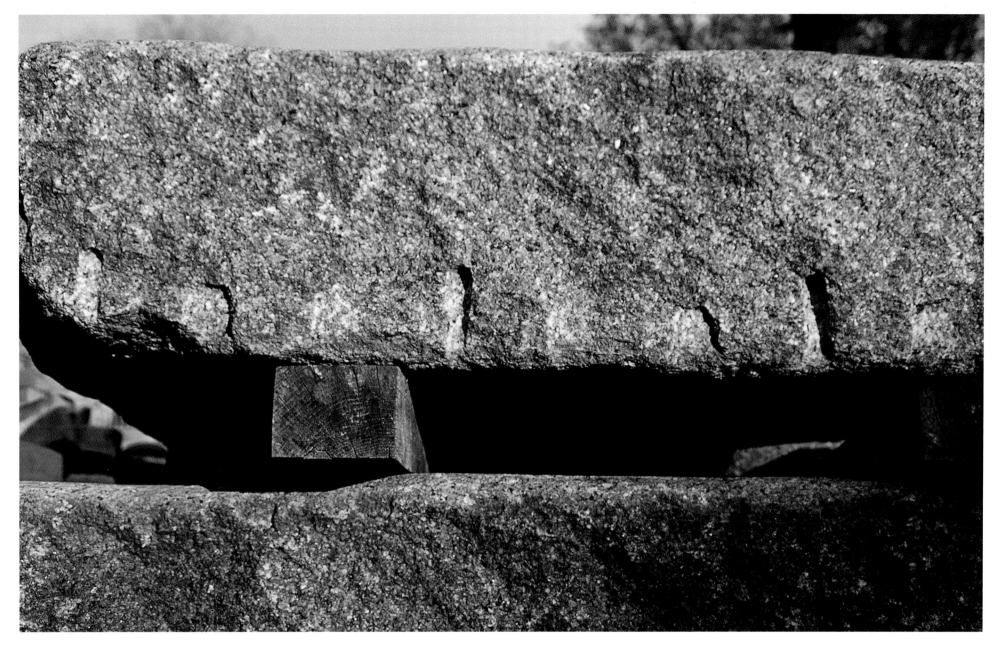

An unusual piece of cut granite shows both the half-round marks of the drill used in the pin and feathers technique, as well as the trapezoidal marks of a cape chisel, which creates a flat-sided hole rather than a round one. The cape chisel is "V" shaped and cuts a narrow, rectangular shaped hole about two inches long at the top by three-eighths of an inch wide. The angle of the chisel was changed while being hammered, creating this uniquely shaped hole. Rather than using a square pin driven between the two feathers (or shims) to split the stone, the cape chisel method uses a flat wedge that, in cross-section, looks a bit like an ax blade, which is pounded in between two shims. The cape chisel was adapted to steam-powered machines in the late 1800s.

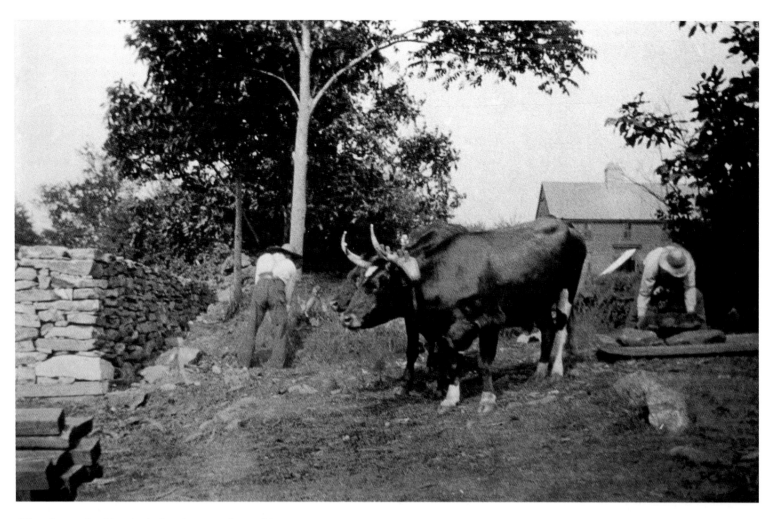

The pictures in this matched pair were taken a bit more than one hundred years apart. The left-hand image from 1902 shows a new wall being built, the two wall builders, their team of slow-moving, but wonderfully strong oxen, and the stone boat—a flat wooden sled onto which stones were rolled for transport to the work site.

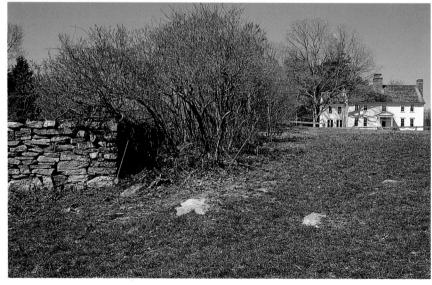

This picture from 2005 shows that the wall has withstood well the test of time. The wall seems to have settled some four inches into the soil, or a century's deposition of vegetative matter has increased the topsoil layer. The truth probably lies somewhere between the two.

Never doubt a Maine Yankee's ingenuity! There is no record as to how well this wall building machine (c. 1904) worked, but it certainly looks like they've thought of everything. Author William Bunting, from whom I learned about this photograph, writes, "Certainly this farm possessed a great wealth of stone. What is not so certain is whether viewing this photo would more likely inspire a Maine farmer to innovate or emigrate."

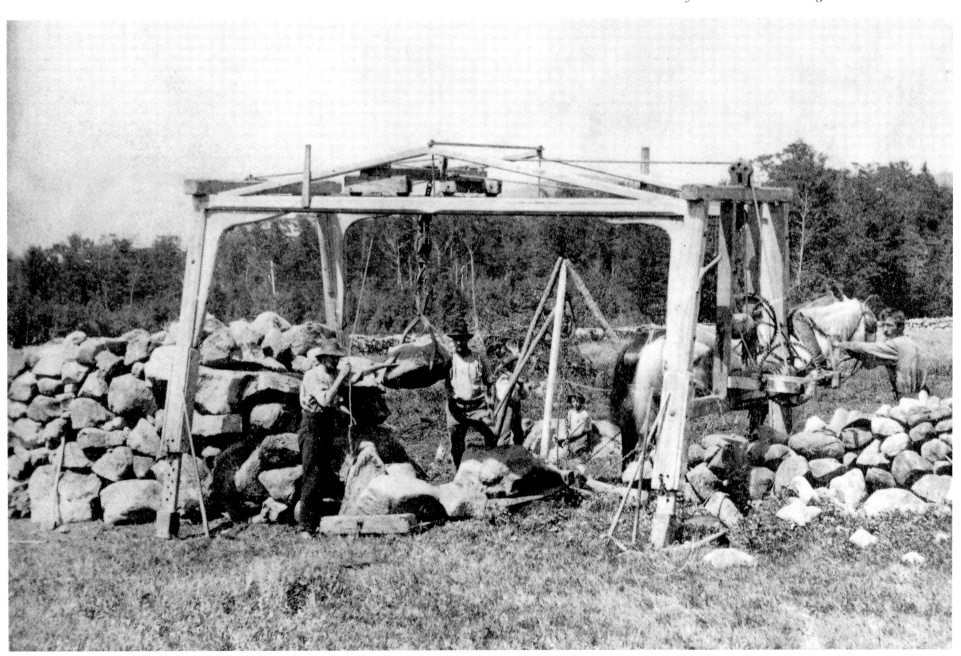

This truly extraordinary wall in Tamworth, New Hampshire, is remarkable for its sheer size. Tamworth is where Grover Cleveland, the 22nd and 24th president of the United States, had his summer home on a hilltop, overlooking New Hampshire's eastern mountains. The wall runs for more than five hundred yards along the downhill side of the road leading up to the house in the upper left. Only the three feet of the wall's freestanding height is seen from the road. The other seven to ten feet is a retaining wall, hidden on the downhill side and holding the road in place.

A period photograph of the wall and Cleveland Hill Road, just after its completion in 1910.

Tom Cleveland, grandson of the president, in a passthrough built into the wall. The estimated weight of the stone to Tom's left, using the figure of 165 pounds of granite per cubic foot, is more than one ton.

How were stones weighing up to two tons put in place without modern equipment? A photograph from the Cleveland family album gives the answer—a gin pole derrick.

A period view of the same passthrough shows the wall has barely changed.

Clearly evident on the face of each of the wall's larger boulders is a small, chiseled dimple, echoed by one on the reverse side. Lifting hooks resembling a pair of ice tongs attached to a rope fit into the dimples. The rope led to the derrick through an efficient block and tackle system to a hand-cranked winch that could raise an amazing amount of weight. Once the stone was raised, the arm of the derrick could be swung to place the stone where needed.

CEMETERIES

Stone walls give cemeteries the dignity they deserve. In the countryside, walls tend to be simple affairs, as is this one in Bridgewater, Vermont.

On a hillside eight hundred feet above Warner, New Hampshire, lies the Kittredge family cemetery, abandoned some one hundred fifty years ago. The walls, poor as they may be, still give the space a sense of sanctity.

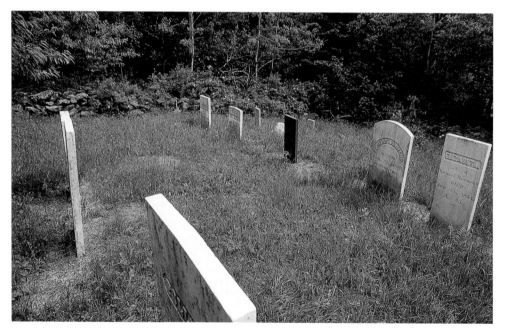

This old burial ground near the Canadian border in Colebrook, New Hampshire, is enclosed by a meager wall. I had expected to find many walls in northern New England, but they were scarce, apparently for two major reasons: the land was less adaptable to agriculture than to raising trees, and much of it was not opened up until after the invention of barbed wire, a far more efficient material for fencing than stone.

For its remote location on the Maine border, this Chatham, New Hampshire, cemetery wall is remarkably sophisticated. It is enclosed by massive blocks of cut granite, some sixteen feet long, two feet high, and nine inches wide, that were quarried from a mountain some fifteen hundred feet above their final resting place. In the late nineteenth century it must have been quite a feat to get them moved.

Often it seems that the roadside walls get the best treatment, as with this one at the Eaton Center cemetery in New Hampshire. Cut stone blocks greet the public, while plain old fieldstone walls make up the rear.

A venerable quarried drystone wall in Goshen, Connecticut, sets off a cemetery with dignity and solemnity.

109

WET WALLS

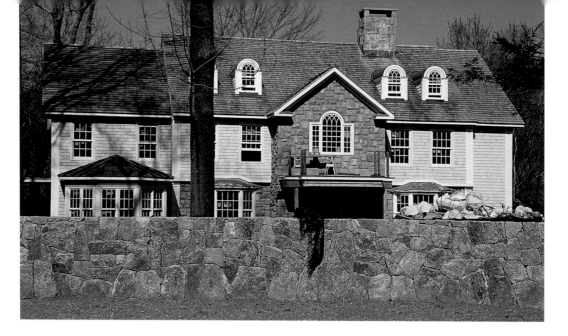

There are degrees of "wetness" when it comes to laying up walls with mortar. If required, the best wallers will use mortar sparingly, building the wall tightly as if no mortar was needed, then sealing perhaps only the top surface for protection from debris, water, and theft. At the other end of the scale are constructions like this veneer wall, where the mortar is applied as a glue.

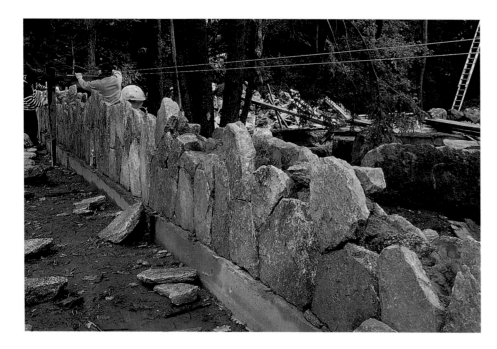

The center of the wall is filled with rubble and the sides artfully fitted in a mosaic pattern, but the strength of the wall comes from the binding properties of the mortar, not from the pull of gravity. "All mortared walls," says Robert Thorson, "are disasters waiting to happen." If the acidity of the rocks and rain don't dissolve the chemical bond between the mortar and the stones, then natural movement created by freezing and thawing or tree growth will, in time, bring down a rigid, mortared structure.

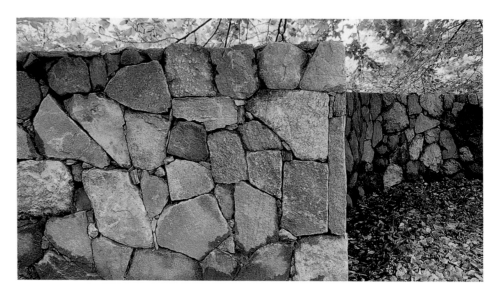

The dead giveaway of a veneered wall is when one can see a thin slab, such as that on the corner of this wall which appears to be standing vertically, somehow magnetically attached to the stones around it.

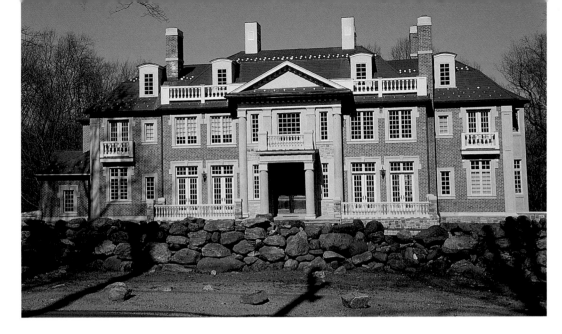

Only a few blocks up the street from the veneered-wall home (opposite) is this new edifice being built in a southern Connecticut town. Whether the old drystone wall in front remains in its current condition will become clear in time. What appears obvious, however, is that fashions of stone walls, like hemlines or hairdos, are subject to change.

It seems inevitable that wet walls, built with the mortar acting as glue, will eventually fail, as has this one in Cumberland Foreside, Maine. Robert Thorson writes in Exploring Stone Walls, ". . . cement is essentially a lime-based artificial material, sworn enemy to acidity of New England's rains (4.5–5.0 pH) and to its soil moisture. But even if rainwater were distilled to neutrality, the lime would still react with the common silicate minerals (in the wall's stones) to produce acidic clay and dust." The gluing effect of the cement will be negated. While patching such a wall might delay its demise, it will look terrible and only forestall the inevitable.

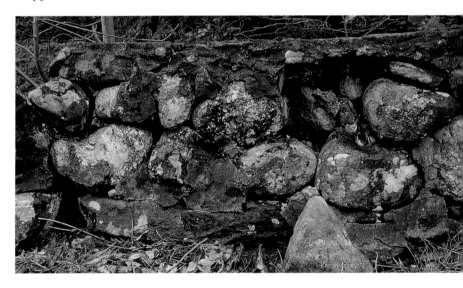

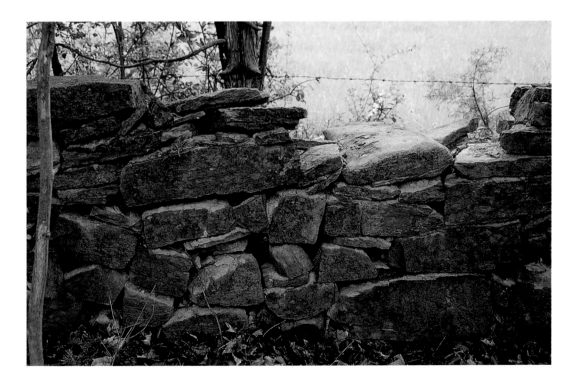

This was once a "wet" wall in Vergennes, Vermont, but due to the total failure of the cement, only the flat stone matrix is standing today. Rebuilding this would not be too difficult, but imagine if the mortar had only partially dissolved. "Mortared walls, when they begin to deteriorate," says Kevin Gardner, "are extremely difficult to do anything with unless you pound them apart. A hideously expensive process."

DRY WALLS

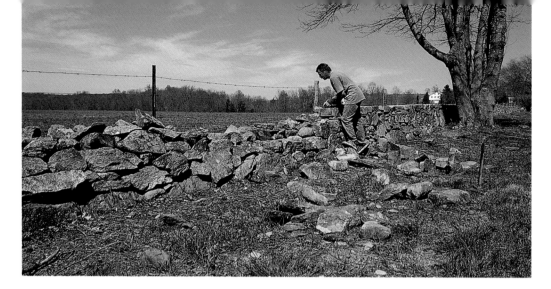

Drystone walls are laid up without mortar. Gravity keeps everything in place. "Stones want to move toward the center of the earth," says Kevin Gardner. So . . . "dry walls need a certain amount of mass to hold together—a three to two ratio is good. If the wall is to be six feet high, it needs to be four feet wide." This waller is rebuilding a wall, taking advantage of the original foundation.

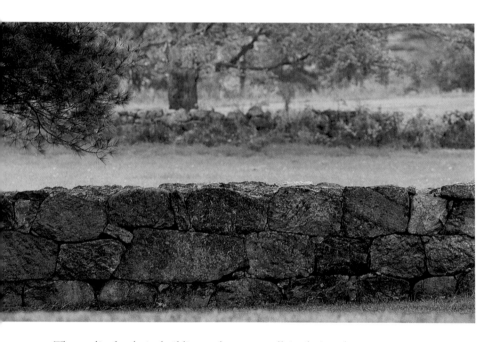

The cardinal rule in building a drystone wall is placing the stones "one over two, two over one." Given New England's terrible mishmash of stones, this rule is hard to follow, but this wall in Harwinton, Connecticut, demonstrates that principle well. If possible, each stone in a wall should rest solidly against at least two others. Wallers avoid a **stack bond** that relies on one stone upon another upon another, creating a **vertical running joint**, visually ugly and structurally ruinous. The most valuable structural stone is a **through-stone** which runs horizontally through the wall every few feet or so, tying the whole assemblage together.

The norm in foundation building used to be to place the largest rocks at the bottom of the trench. But one Vermont farmer, ". . . put them little stones in the bottom and then his big stones on top of 'em. Then when it did freeze, they'd roll around on them little stones, but didn't roll enough to upset the wall." Today crushed rock is the most frequently used foundation base.

One advantage of dry walls is that they can be taken apart and reassembled. I often passed this house, but paid it no attention until it was suddenly dressed up with this wall of reused cut granite. Only then did I learn that—built around 1730—it is the oldest continuously inhabited house in the city of Portland, Maine.

WALL BUILDER: JOHN TRIMARCHI

Much of this book has been focused on the antique walls of New England. But what is going on in the realm of modern construction? Meet John A. Trimarchi, owner of Trimarchi Nurseries and Landscape Stonework in Adams, Massachusetts. He earned his bachelor's degree in landscape architecture from the State University of New York College of Environmental Science and Forestry at Syracuse. "When I opened the business in 1994, we didn't do stonework," John says. "It was mostly tree and shrub planting. As we got into the business, people would often ask, 'Can you build us a patio or retaining wall?' Our first few responses were, 'No, sorry we don't do that type of work.' Then so many clients were asking, I decided I'd better learn."

John is very thorough. He draws many landscape projects on paper before ever picking up a stone. He finds that much of his business is building new retaining walls, "landscaping walls" he calls them, built with quarried stone, field stone, and any other stones that might be available. He points out that, "I've noticed a recent positive acceptance of more creative stonework in new residential construction. At first we built mainly straight walls, but now we're building more curved walls, curved steps, arches—stone is a flexible building material."

John Trimarchi with a combination of drystone stairs, freestanding wall, and retaining wall he built in North Adams, Massachusetts.

As we drove through the rolling Berkshire countryside near his home in western Massachusetts, John said, "Now, take a left here and we'll go up this steep dirt road. There's something in the woods we call High Bridge that you'd be surprised to see." I parked the car and we walked through the forest down toward the sound of rushing water. The ground suddenly fell steeply away on each side of the track. We came to an abrupt halt. The lane had fallen away in front of us as well. We were standing on the brink of what had been a bridge abutment, more than two stories above a rushing brook.

"Let's go down to look at this structure from its base," John suggested. From below, this man-made boulder retaining wall towered about twenty-two feet above us. "The other side of this bridge abutment collapsed long ago. I would guess this remaining wall is around a hundred years old," John explained. With a degree of awe and respect in his voice he continued, "The old-timers who built the walls we see in the woods today were, if anything, fearless. I'm more cautious about the size of the stones I'm willing to build with or the height I'd be willing to build." Then he adds with a laugh, "I don't think I'd attempt the High Bridge today."

I asked John to define the characteristics of a good waller. "Patience," was his immediate response. "Patience and a good sense of what is level. Understanding that the pull of gravity is straight down. A stone's central mass in a wall shouldn't really be leaning forward out of the wall. Nor do you want it leaning side to side. Instead, it should lean slightly back, especially in a retaining wall. You've got to have a sense that that stone is going to sit tight, pulling itself straight down."

He continued, "Building a good drystone wall does take a lot of practice, hand/eye coordination, understanding spacial relations, and listening. We're always listening. If the stone is going on the wall poorly, it sounds hollow. If it is a well placed stone, you can hear a satisfying thud as it seats itself against the other stones. When they are going in right, you can hear it."

John is proud to help mentor, and to learn from, some part-time wallers he has employed. "Many of my employees have been high school and college students who have continued to call back for work during their breaks from school. I think I can speak for most when I say the more you do the easier it gets, almost like play rather than work. I am thankful to have the loyal friendships that were formed while working on some seemingly insurmountable landscaping projects."

John concluded by voicing a feeling that all good wall builders must experience, "There's a lot of satisfaction when you see the wall up and it's standing strong. The client is happy and I'm happy—and looking forward to the next stone wall!"

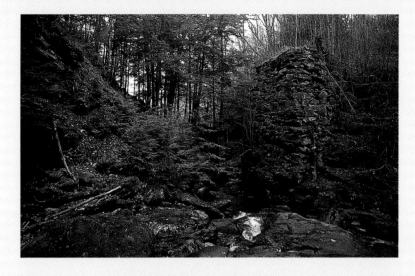

The remains of the nineteenth-century High Bridge.

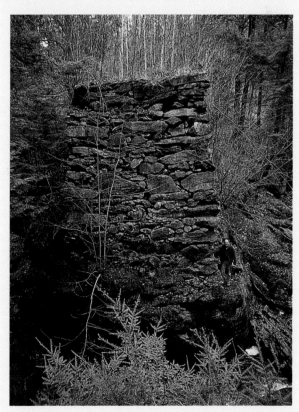

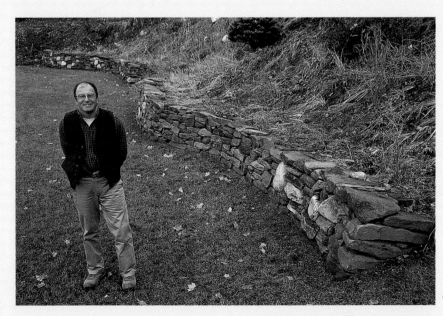

"The client is happy and I'm happy!"

Author's Note

I've often pondered the similarity between a well-made drystone wall and a well-lived life. Both depend on a solid foundation. There are some walls, and some people, who are fortunate enough to come into the world close to solid bedrock. Others have to dig deep to stabilize their base, to accumulate rip-rap in the form of life experiences, and build a bedrock of their own. Walls, like lives, are strengthened by these bits and pieces of experiences from the school of hard knocks—and together, they create a sturdy platform on which to grow.

Given a solid starting point, the building begins. For the wall, the largest stones go in first, laid carefully and true. For the person, the components are equally large and basic: a nurturing family, and the development of social skills, facility with language, and educational fundamentals.

Maturity comes slowly with careful placement of the building blocks, filling in the empty spaces with well-selected filler experiences, making sure the components all touch each other in as many ways as possible. With people, as with walls, square and straight may not be exciting attributes, but they make for very solid citizens.

No matter how striking a wall or a person may look from the outside, if the core elements are assembled without the discipline of tightly interlocking interior pieces for solidity and strength, the wall—or the person—is prone to suffer a shortened or less successful life.

Even in our older years we find similarities in comparing our lives with those of walls. We start turning gray around forty. Our various parts loosen up. Some even fall out. Our surfaces dry out and might grow scaly. Our bottoms spread. Our once straight-backed posture becomes more rounded, less stable. Yet, while we may not last much more than the proverbial three score and ten, our friends, the walls, have the potential for lasting decades or even centuries. Long live us both!

Suggested Readings

Allport, Susan. *Sermons in Stone: The Stone Walls of New England and New York*. New York and London: W. W. Norton, 1990. ☐ Allport was among the very first authors to sense the growing interest in stone walls by the general public. This eminently readable book combines thorough historical and scientific research with the narrative of a great novel.

Bell, Michael. *The Face of Connecticut: People, Geology, and the Land*. Hartford, Connecticut: State Geological and Natural History Survey of Connecticut, 1985. ☐ Bell's book details the Connecticut landscape with X-ray eyes, giving the reader a wonderful sense of what did happen, and is happening, to make the state look as it does.

Bunting, W. H. *A Day's Work: A Sampler of Historic Maine Photographs, Parts I and II*. Gardiner, Maine: Tilbury House, 1997. ☐ An amazing collection of antique photographs of workers in Maine, along with an equally astounding amount of anecdotal information that makes the pictures come alive.

Caldwell, D. W. *Roadside Geology of Maine*. Missoula, Montana: Mountain Press Publishing Company, 1998.

Cronon, William. *Changes in the Land: Indians, Colonists, and the Ecology of New England*. New York: Hill and Wang, 1983. ☐ A scholarly and readable reference on the effects of colonization on the New England landscape.

Fields, Curtis P. *The Forgotten Art of Building a Stone Wall*. Dublin, New Hampshire: Yankee, Inc. 1971.

Gage, Mary and James. *The Art of Splitting Stone: Early Rock Quarrying Methods in Pre-Industrial New England*. Amesbury, Massachusetts: Powwow River Books, 2002. ☐ A short, soft cover book with excellent descriptions of how colonists split stone.

Gardner, Kevin. *The Granite Kiss: Traditions and Techniques of Building New England Stone Walls*. Woodstock, Vermont: The Countryman Press, 2001. ☐ Even a city dweller would enjoy reading this extremely literate and well-crafted book that covers the philosophical and artistic, as well as the practical aspects of building a wall, written by a practicing wall builder.

Hastings, Scott E., Jr. *The Last Yankees: Folkways in Eastern Vermont and the Border Country*. Hanover and London: University Press of New England, 1990.

Jager, Ronald. *Last House on the Road: Excursions into a Rural Past*. Boston: Beacon Press, 1994.

Jorgensen, Neil. *A Guide to New England's Landscape*. Chester, Connecticut: The Globe Pequot Press, 1977.

Kay, Jane Holtz. *Preserving New England*. New York: Pantheon Books, 1986.

Russell, Howard S. *A Long, Deep Furrow: Three Centuries of Farming in New England*. Hanover and London, 1982. □ An excellent history of New England farming, loaded with original source materials.

Snow, Dan. *In the Company of Stone: The Art of the Stone Wall*. New York: Artisan, 2001. □ Snow is a master drywall builder and a truly creative artist. This large format book of excellent photography of his work, along with Dan's eloquent words, is a treasure.

Stone Wall Initiative (SWI), http://stonewall.uconn.edu
A Web site, clearinghouse, and information center for New England's stone walls.
Coordinator: Professor Robert M. Thorson.

Thorson, Kristine and Robert M. *Stone Wall Secrets*. Gardiner, Maine: Tilbury House, 1998. □ A winning tale for young readers that painlessly delivers an amazing amount of information about geology, natural science, and anthropology.

Thorson, Robert M. *Stone by Stone: The Magnificent History of New England's Stone Walls*. New York: Walker & Company, 2002. □ Thorson's prize winning book is packed with scientific information, presented in a most palatable form. *Stone by Stone* provides answers to most every question you've ever had on the subject, delivered with clarity, scientific accuracy, philosophical wisdom, and humor.

Thorson, Robert M. *Exploring Stone Walls: A Field Guide to New England's Stone Walls*. New York: Walker & Company, 2005. □ A pocket guide that covers much of the information in *Stone by Stone* with the addition of black and white pictures and a handy system for naming and classifying wall types.

Vivian, John. *Building Stone Walls*. North Adams, Massachusetts: Storey Books, 1976.

Wessels, Tom. *Reading the Forested Landscape: A Natural History of New England*. Woodstock, Vermont: The Countryman Press, 1997. □ The clues Wessels gives for discerning what happened to the New England scene before the reader arrived makes any trip through the countryside a mystery-solving adventure.

ACKNOWLEDGMENTS

Covered bridges and lighthouses are easy to find. They are even marked on maps. Not so when it comes to finding interesting stone walls. It has been a long, slow process that would be still ongoing were it not for the generous and knowledgeable assistance of literally hundreds of people across six states. While I can't name them all, here are those who contributed most to the completion of this work.

My very special thanks go to the six wall builders who so graciously gave of their time to show me their work and to give me the interviews that appear at the end of each chapter: Craig Aronson, Tim Currier, Kevin Gardner, Ted Peach, John Trimarchi, and Michael Weitzner.

In my suggested readings list, the works of three authors stand out: Susan Allport, Kevin Gardner, and Bob Thorson. I thank them also for doing me the honor of checking facts and figures in *Good Fences*. Should there be any errors, I claim them completely as my own.

In Connecticut the following historical society people were most helpful: Carol Ann Brown (Bethlehem), Bernadette Allingham and Dorothy Gustafson (Bridgewater), E. R. Knowlton (Brooklyn), Margaret Wood (Goshen), Linda Hocking (Litchfield), Scott Breed (Stonington). People at other organizations were John Nelson (Bethlehem Land Trust), Laurie Nash and Janet Serra (Connecticut Visitors Bureau), Margaret McCauley (Nature Conservancy in New Milford), Susan Bramson (Steep Rock Association), as well as park ranger Chris Gezon (Weir Farm National Historic Site in Wilton.) Among the network of friends old and new who helped me find wall treasures were John Clark in Bantam, Max Miller in Higganum, Carol and Chip Dahlke of Lyme, David and Tony Bingham of Salem, and David Rathbun in Stonington.

In Maine, my home state, I relied on friends new and old, including author Bill Bunting, Jeff Carpenter, Ed Churchill of the Maine State Museum, Fred Field, Mike Foley, Mary Jo Marquis, Debbie Molander, Richard Pulsifer, Bob Stewart, and Norman Weymouth.

In Massachusetts, surely a historical state, help came from people at different historical societies: Myron Goddard (Hardwick), Betty Hunt (Marblehead), Vera Cross (Sharon), and Sharon Whypych (Westport). People at organizations which made my life easier and more fun were Dr. John O'Keefe (Harvard Forest), Christine Turnbull (The Massachusetts Audubon Moose Hill Wildlife Sanctuary), Ed Hood (Old Sturbridge Museum), and Tremaine Cooper who lives at one end of the Brothers' Walk. On Martha's Vineyard, special thanks go to David Murry and Jim Powell.

In New Hampshire, I especially enjoyed working with Joan Little of the Sandwich and Rececca Courser and Linda and David Hartman of the Warner historical societies. Nancy Boetticar of the Chocorua Public Library and Michael French of the Canterbury Shaker Village added important new insights. Tom Cleveland and his sister Charlotte Look contributed greatly by sharing images from the Cleveland family archives. My thanks go also to Virginia Weber and to Kathleen Shea of the New Hampshire Farm Museum.

In Rhode Island I was given welcome support from Fred Bridge of the Little Compton and Bernard Fishman of the Rhode Island Historical Societies. Friends old and new Carl Acebes, Carlton Brownell, Bill and Nancy Easman, and William Middendorf granted me access to their wonderful walls.

In Vermont, a state with marvelous walls, but many I could find on my own, I wish to thank Betsy and Bill Benton and Jason Hatch of Vergennes, Bob and Ann Davidson of Burlington, Bob Hold of Woodstock, Dan Snow of Dummerston, and, especially, my sister, Anne French of Norwich.

And deepest thanks to these stalwart souls who worked with me on this book from start to finish—editing, proofing, suggesting, encouraging, and often, wringing their hands: Heidi Lackey, who produced countless slide labels; my daughter Drika for the author's jacket photograph; Dave Lackey, who tightened up sloppy writing and guided me out of verbal dead-ends; Carol OBrion who cheerfully suffered through innumerable changes as she laid out the book with admirable artistry and precision; my thorough and always helpful editor Michael Steere at Down East Books who proposed the project, and lastly to my loyal and ever-patient wife Jeannie for her love and support. My heartfelt gratitude to you all.

PHOTOGRAPHIC CREDITS

All photographs are by the author except the following:

Page 12	Ellesmere Island in the Arctic Ocean: Wilfred E. Richard © 2001.
Page 13	Face of the Childs Glacier at Copper River Delta, Alaska: photograph © Gary Braasch-Woodfin Camp. Photocomposit by Robert Marciniak.
Page 24	Nineteenth-century stump fence: From the collection of W. H. Bunting. The location of the original image is unknown.
Page 42	Antique photograph of the Brothers' Walk: courtesy of Tremaine Cooper.
Page 104	Antique photograph of two wallers and a team of oxen by Hiram Bingham III, circa 1904.
Page 105	Stone wall building machine: W. H. Bunting.
Pages 106, 107	Antique photographs of Cleveland wall: courtesy the Cleveland family/Charlotte Look and Tom Cleveland.